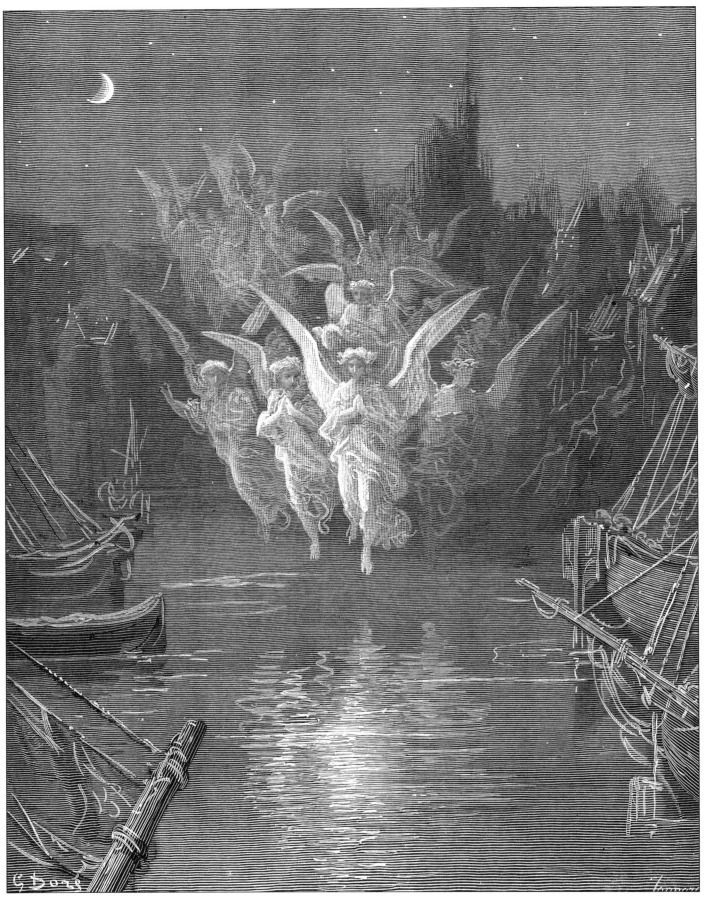

And the bay was white with silent light,
Till rising from the same,
Full many shapes, that shadows were,
In crimson colors came.
 —*The Rime of the Ancient Mariner*

Doré's ANGELS

GUSTAVE DORÉ

Edited by
Carol Belanger Grafton

DOVER PUBLICATIONS, INC.
Mineola, New York

Note

For centuries, angels have been revered as celestial guardians of mankind, offering hope and solace to those in need. These spiritual beings have been portrayed as messengers, aides, warriors, and guides, gracing the heavens—and occasionally earth—with their statuesque beauty. Primarily associated with Western religions and depicted as winged, humanlike figures, angels have often appeared in literature as benevolent agents of God.

In illustrating many of the world's greatest books, Gustave Doré (1832–1883) displayed his own majestic interpretation of angels and their presence in classic stories. Born in Strasbourg, France, on January 6, 1832, Doré's artistic talent became apparent at an early age. As a young child, he would sketch people and street scenes, and—despite his father's wish that he enter a more pragmatic profession—early on decided to make a living from his craft, with his mother's support. At the age of fifteen, while on a family trip to Paris, Doré stopped at the shop of Auber and Philipon, publishers of cartoons and caricatures. He later returned with works of his own, and was immediately recognized as a new talent by Philipon himself. The publisher persuaded Doré's parents to sign the youth to a three-year contract, contributing illustrations to Philipon's new comic paper, *Journal pour rire*.

The success of his work would prove to be critical to the family's survival after the death of Doré's father in 1849. As the sole support of his mother and brothers, Doré forced himself to produce illustrations at a rapid rate, which heightened the demand for his work. By the 1850's, Doré was the most successful illustrator in Paris. Not content with his fame, he further challenged himself with lofty goals, including an unsuccessful one to be a master painter. Another was to illustrate all the classic works of literature, beginning with Rabelais in 1854 and Balzac's *Contes Drôlatiques* in 1855. These were followed by other great books, including *Divine Comedy, Paradise Lost,* and, of course, the Bible. These last three, in particular, were enormously popular and published in many languages.

Though he started off primarily as a lithographer, Doré worked with woodblock engravings for the bulk of his career. His method was to draw a design on blocks, then have others carve it. After too many disappointments with the quality of the engravings, Doré assembled a team of talented youths and trained them to carve his designs to his satisfaction. This team would remain in his employment throughout his life, and their signatures are visible in many of his most important works.

The period of the Franco-Prussian War of 1870–1871 marked a change in Dore's grand lifestyle as a celebrated illustrator. His new forays into sculpture and religious painting were not as well received as his engravings, and several of his closest friends passed away during this time. Ever the prolific artist, he continued to create pieces for his London-based Doré Gallery, while sculpting a monument to his late companion, Alexandre Dumas the elder. A sudden stroke on January 23, 1883 ended his life at the age of fifty-one, leaving unfinished the Dumas memorial and illustrations to a volume of Shakespeare which he had been working on for ten years. Though the creative tide had been abruptly halted, Gustave Doré left behind a large and magnificent legacy of works that continues to inspire, more than a century after his death.

Copyright

Copyright © 2004 by Dover Publications, Inc.
All rights reserved.

Bibliographical Note

Doré's Angels is a new selection of plates, first published by Dover Publications, Inc. in 2004.

DOVER *Pictorial Archive* SERIES

This book belongs to the Dover Pictorial Archive Series. You may use the designs and illustrations for graphics and crafts applications, free and without special permission, provided that you include no more than four in the same publication or project. (For permission for additional use, please write to Permissions Department, Dover Publications, Inc., 31 East 2nd Street, Mineola, N.Y. 11501.)

However, republication or reproduction of any illustration by any other graphic service, whether it be in a book or in any other design resource, is strictly prohibited.

International Standard Book Number

ISBN-13: 978-0-486-43668-5
ISBN-10: 0-486-43668-3

Manufactured in the United States by Courier Corporation
43668304
www.doverpublications.com

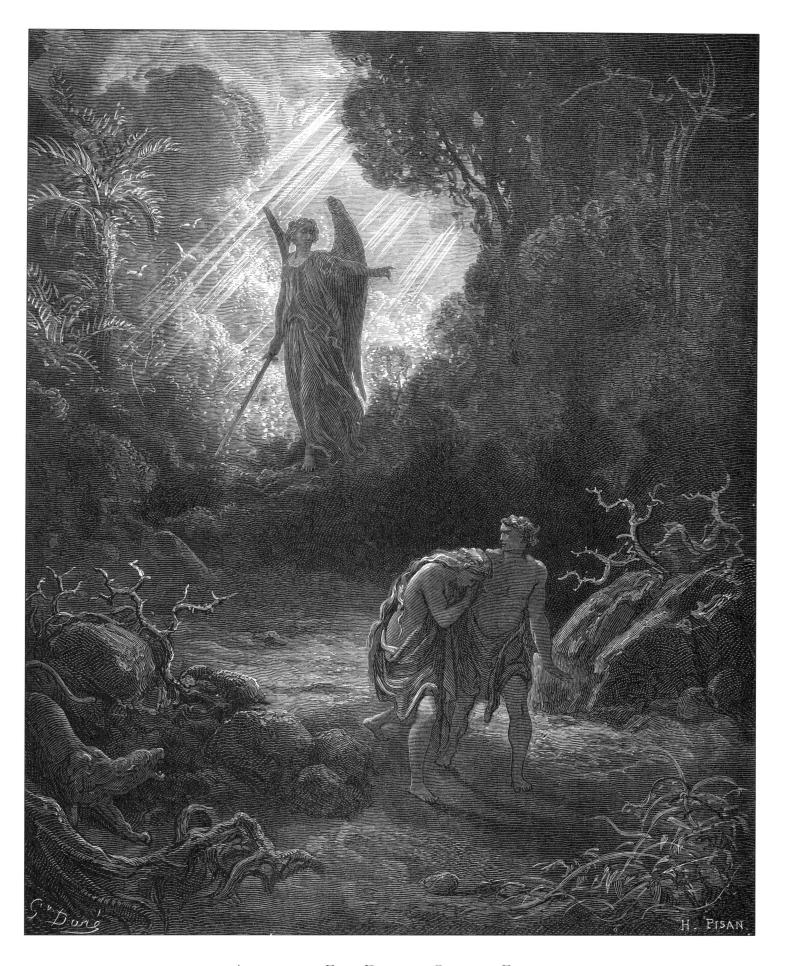

ADAM AND EVE DRIVEN OUT OF EDEN
And he placed at the east of the Garden of Eden Cherubims, and a flaming sword which turned every way, to keep
the way of the tree of life . . . (Genesis 3:24)

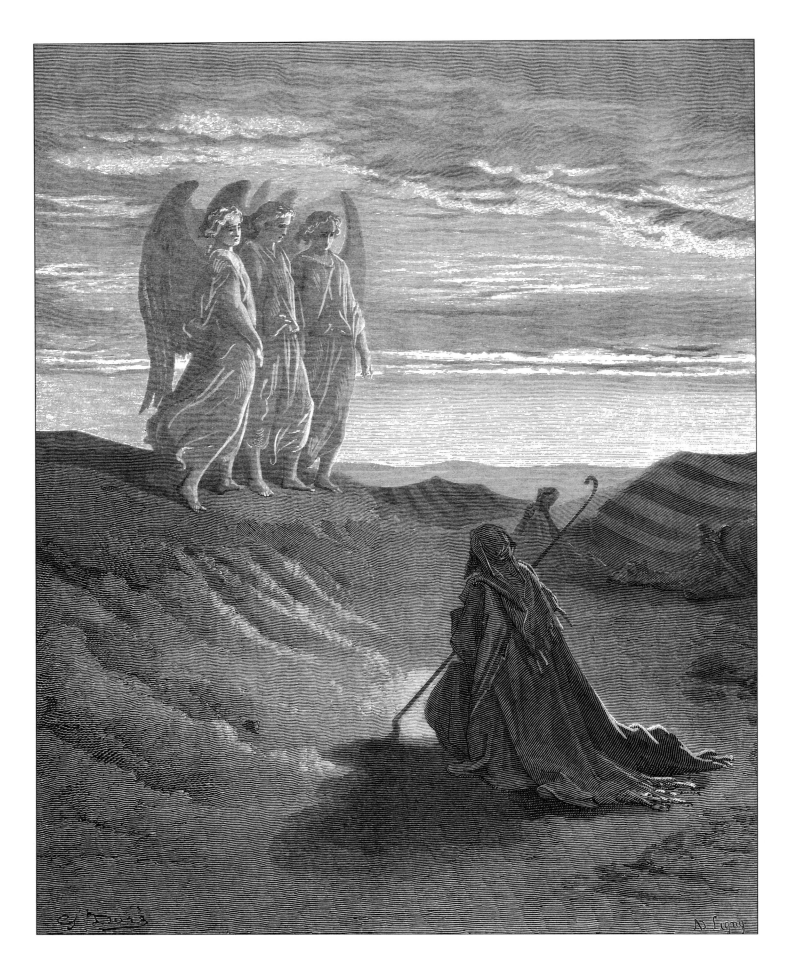

ABRAHAM AND THE THREE ANGELS
And they said unto him, Where is Sarah thy wife? . . . Sarah thy wife shall have a son . . . (Genesis 18:9, 10)

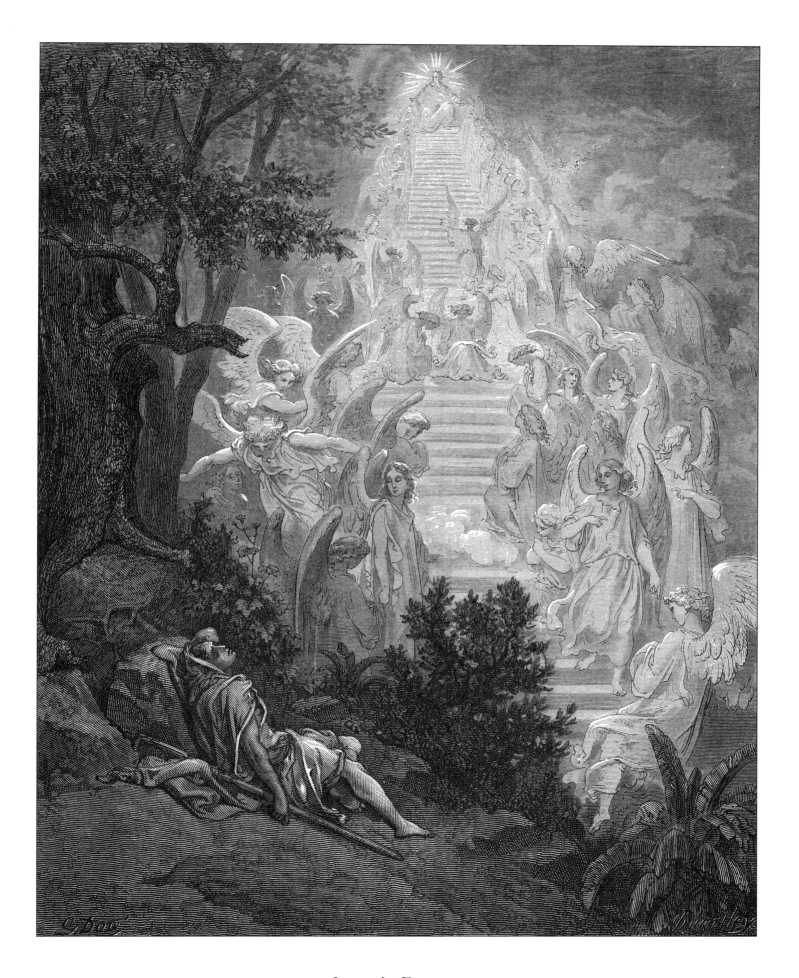

JACOB'S DREAM
And he dreamed, and behold a ladder set up on the earth, and the top of it reached to heaven: and
behold the angels of God ascending and descending on it . . . (Genesis 28:12)

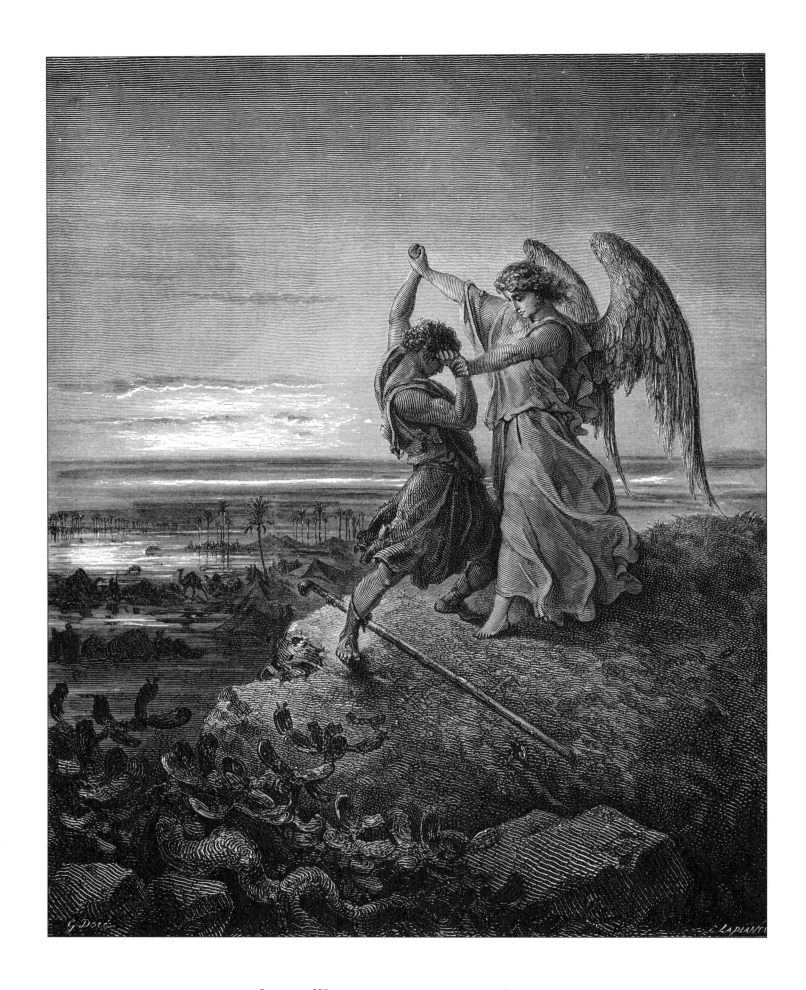

JACOB WRESTLING WITH THE ANGEL

And Jacob was left alone: and there wrestled a man with him until the breaking of the day . . . And Jacob
called the name of the place Peniel: for I have seen God face to face . . . (Genesis 32:24, 30)

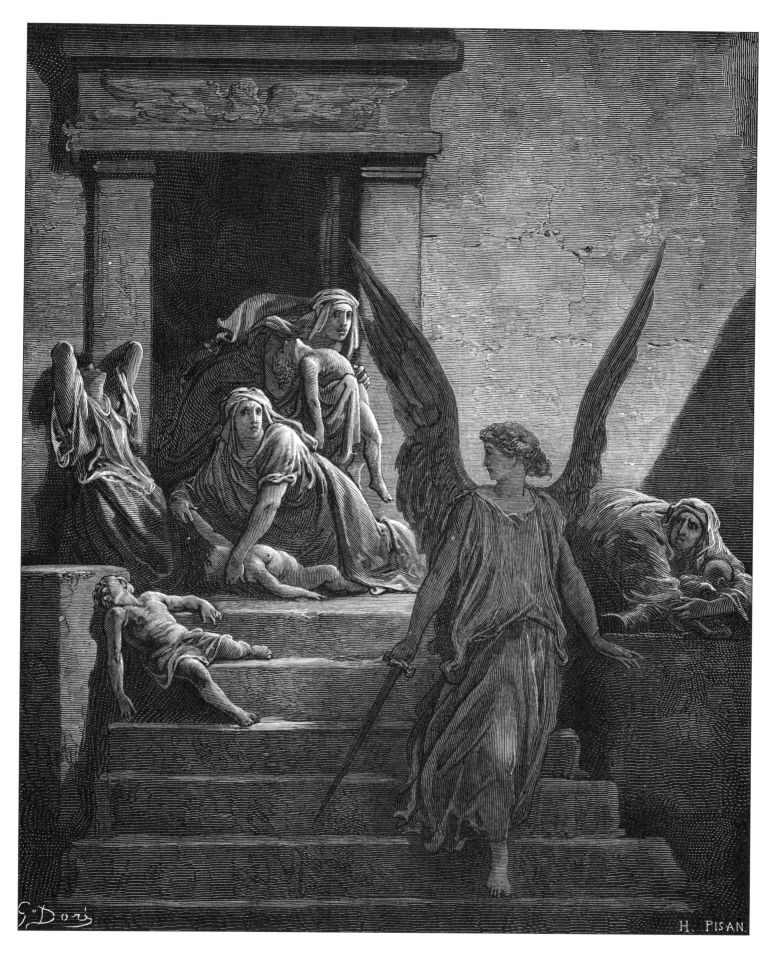

THE FIRSTBORN SLAIN
And it came to pass, that at midnight the Lord smote all the firstborn in the land of Egypt . . . And
Pharaoh rose up in the night . . . and there was a great cry in Egypt; for there was not a house
where there was not one dead . . . (Exodus 12:29–30)

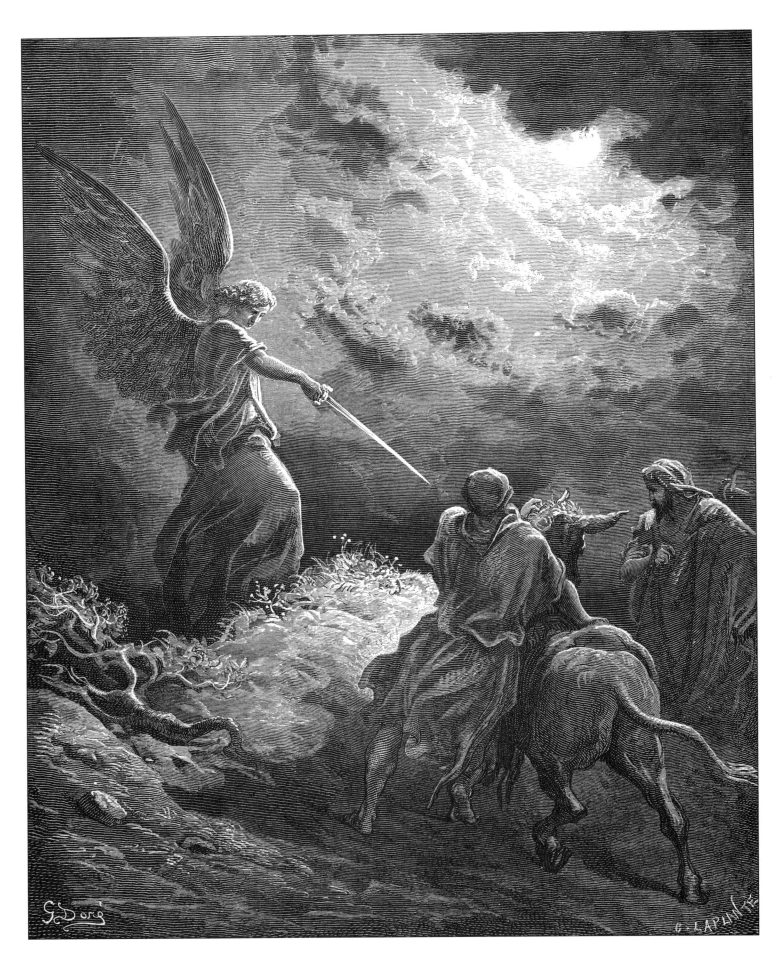

The Angel Appearing to Balaam

And the ass saw the angel of the Lord standing in the way, and his sword drawn in his hand: and the ass turned aside out of the way, and went into the field: and Balaam smote the ass, to turn her into that way . . . (Numbers 22:23)

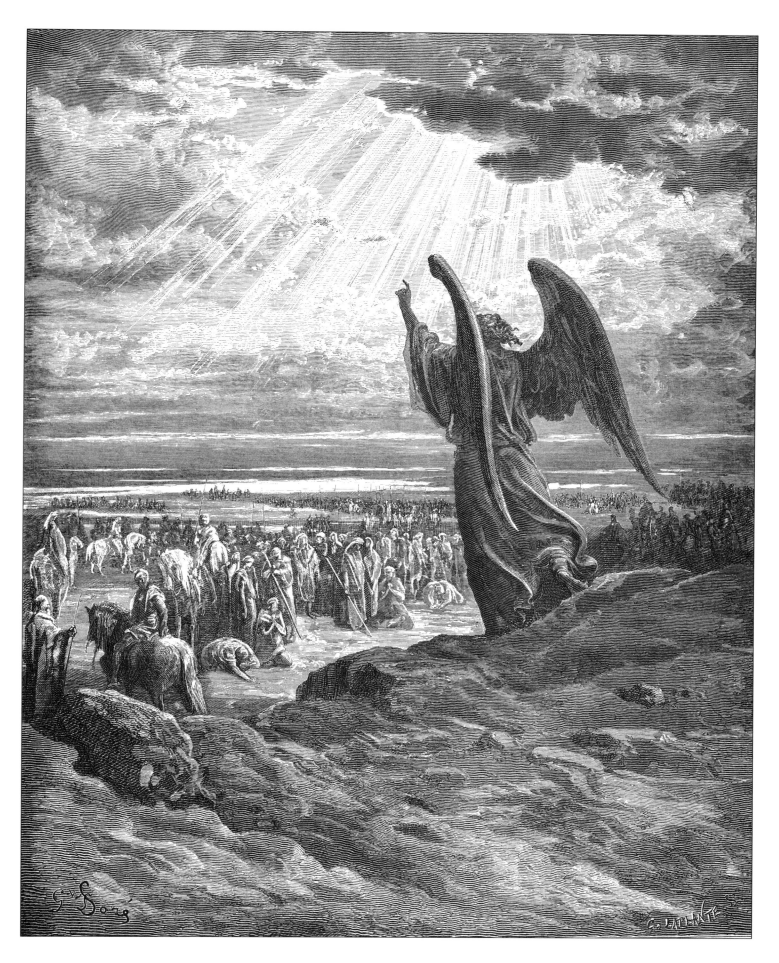

THE ANGEL APPEARING TO JOSHUA

And the captain of the Lord's host said unto Joshua, Loose thy shoe from off thy foot; for the place
whereon thou standest is holy . . . (Joshua 5:15)

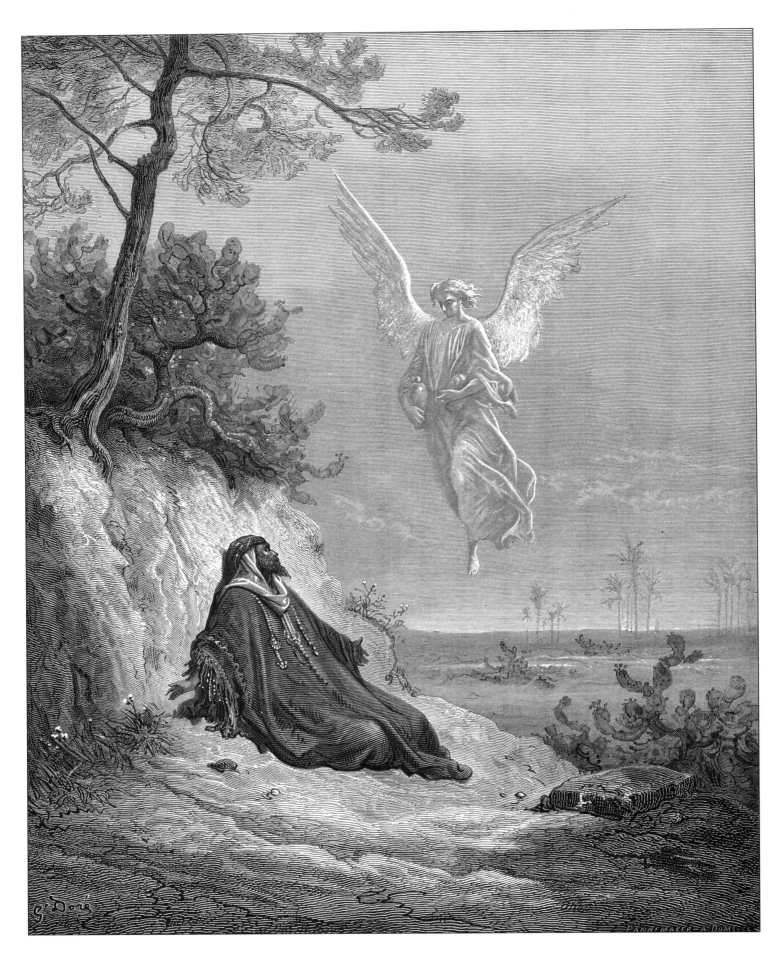

ELIJAH NOURISHED BY AN ANGEL
And as he lay and slept under a juniper tree, behold, then an angel touched him, and said unto
him, Arise and eat . . . (I Kings 19:5)

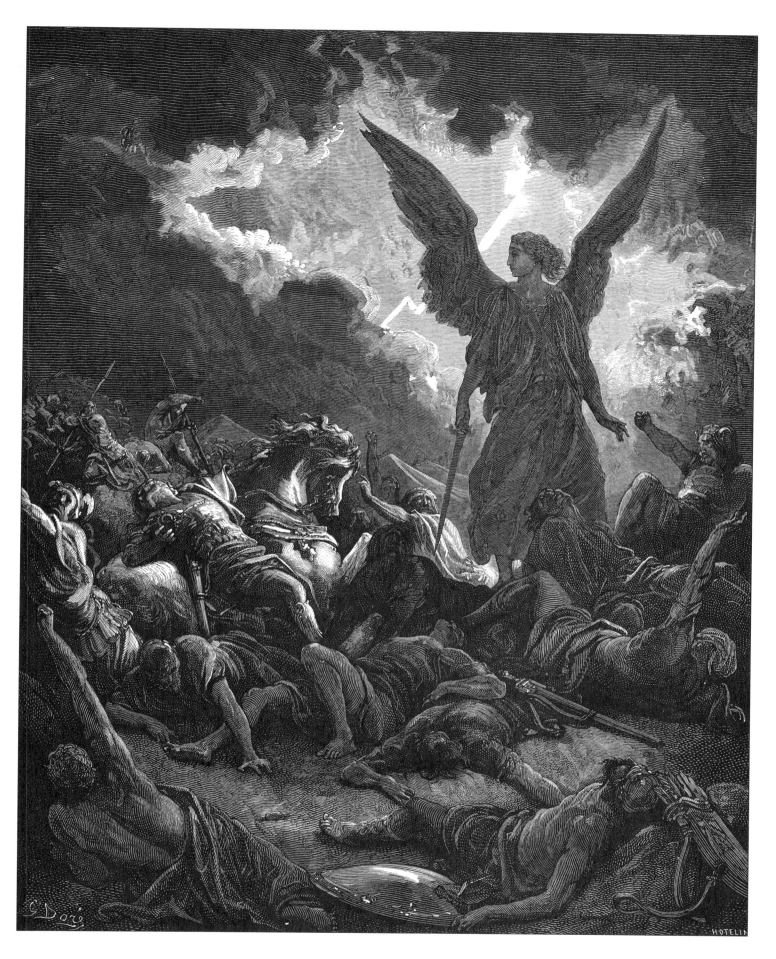

DESTRUCTION OF THE ARMY OF SENNACHERIB

And it came to pass that night, that the angel of the Lord went out, and smote in the camp of the Assyrians an
hundred fourscore and five thousand . . . So Sennacherib king of Assyria departed . . . (II Kings 19:35, 36)

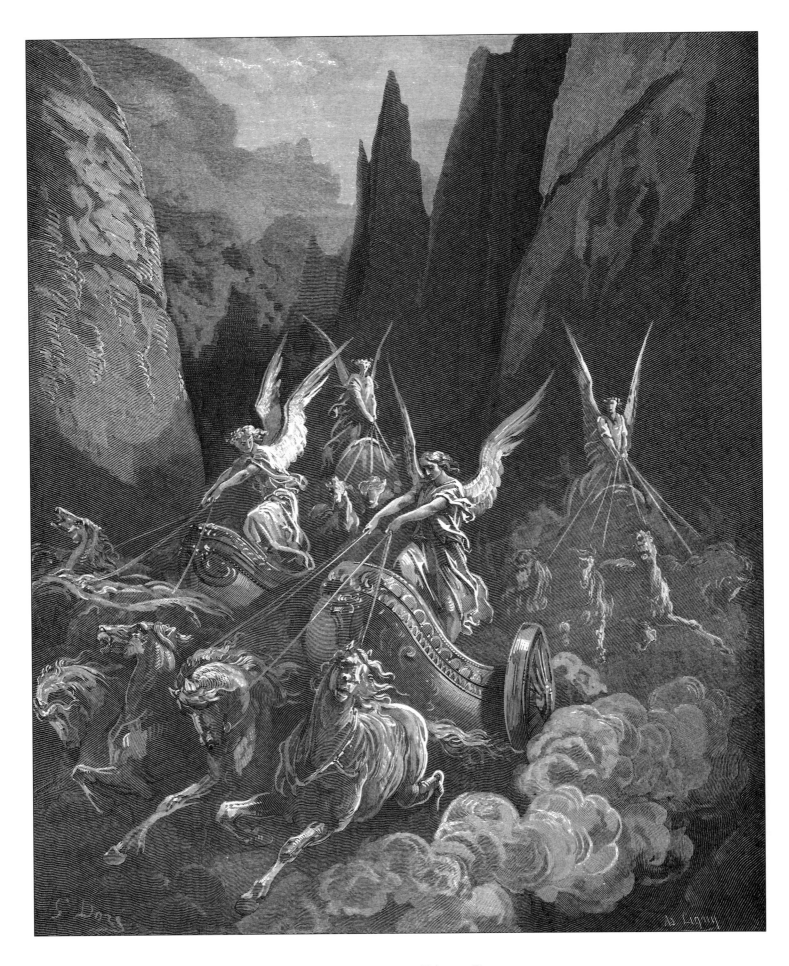

THE VISION OF THE FOUR CHARIOTS

And the angel answered and said unto me: These are the four spirits of the heavens, which go forth from standing before the Lord of all the earth . . . (Zechariah 6:5)

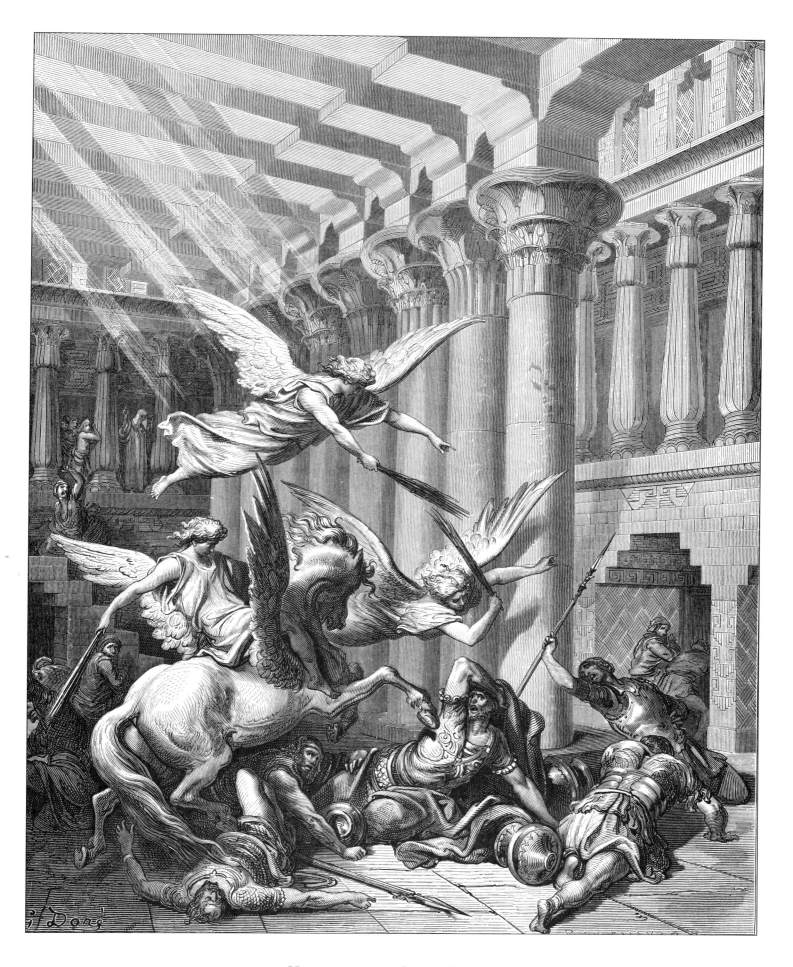

HELIODORUS CAST DOWN

There appeared unto them an horse with a terrible rider . . . and . . . two other young men . . . notable in strength . . .
And Heliodorus fell suddenly unto the ground . . . (II Maccabees 3:25, 26, 27)

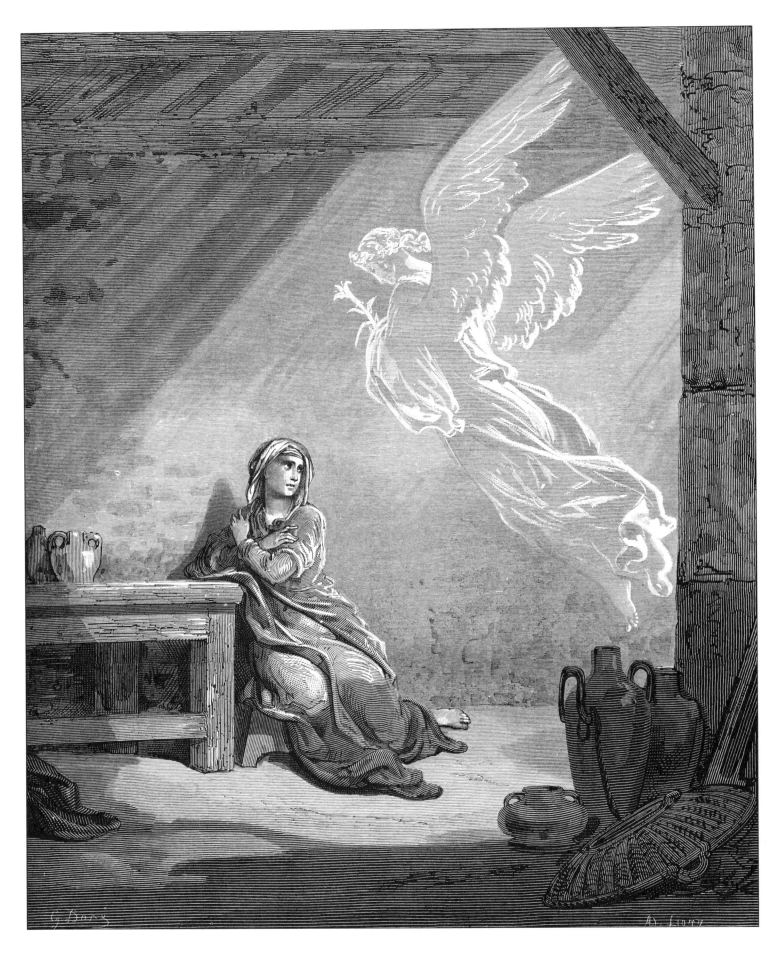

THE ANNUNCIATION
And the angel said unto her, Fear not, Mary: for thou hast found favour with God . . . (Luke 1:30)

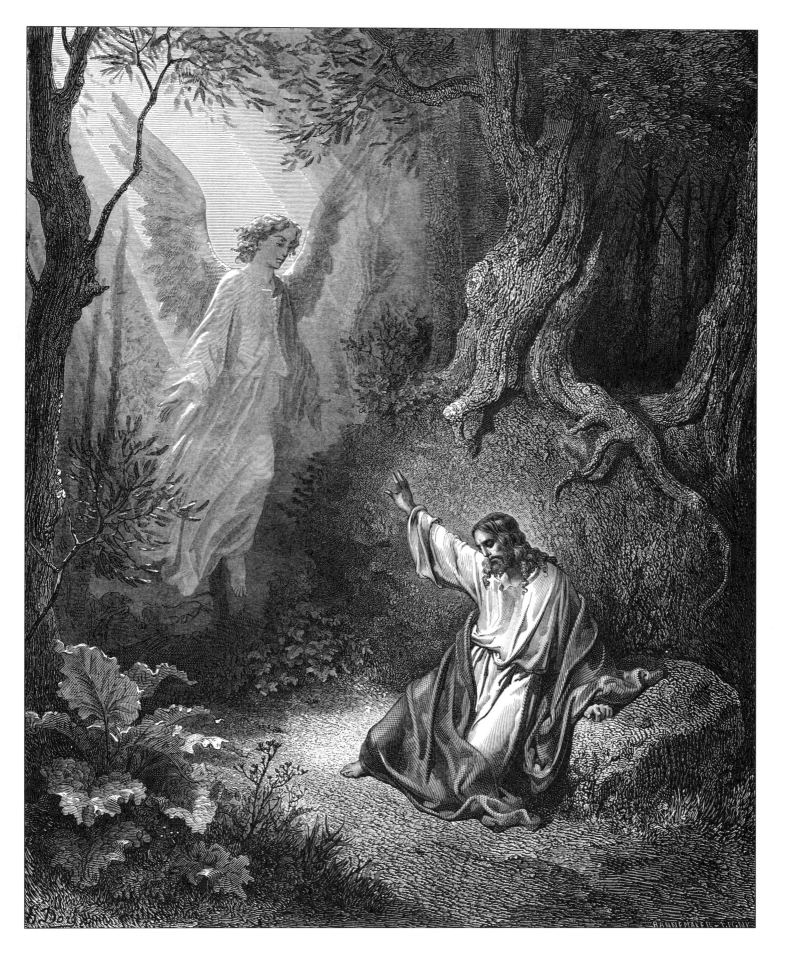

THE AGONY IN THE GARDEN
And there appeared an angel unto him from heaven, strengthening him. . . . (Luke 22:43)

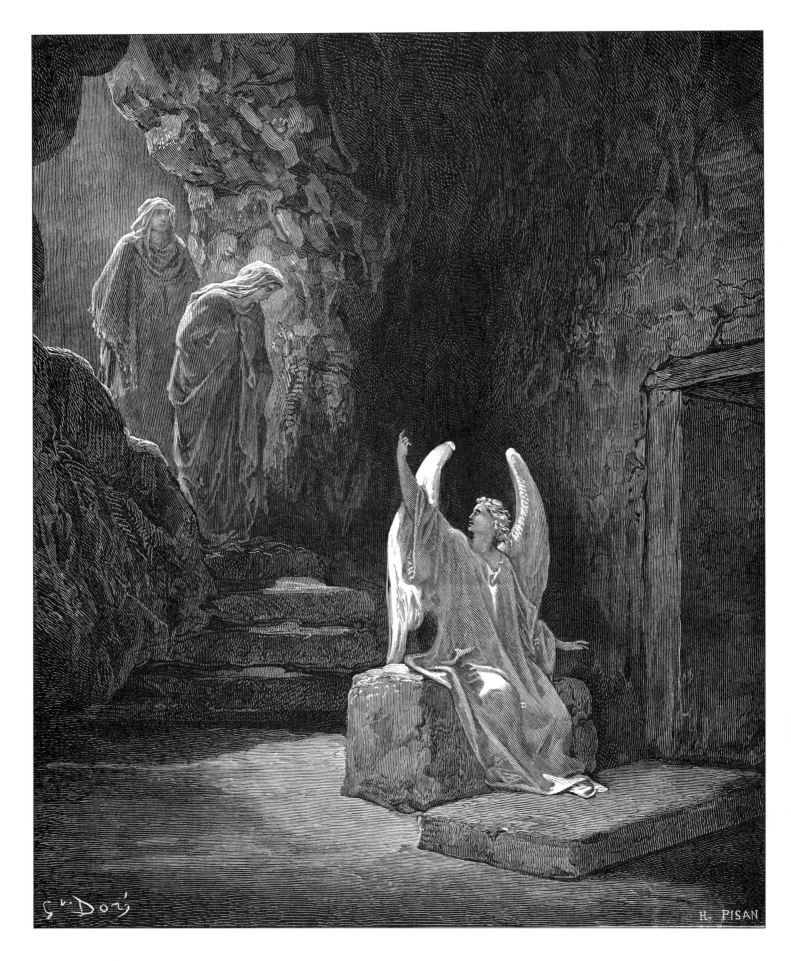

THE RESURRECTION

And the angel answered and said unto the women, Fear not ye: for I know that ye seek Jesus, which was crucified.
He is not here: for his is risen, as he said. Come, see the place where the Lord lay. . . . (Matthew 28:5, 6)

14 | The Holy Bible

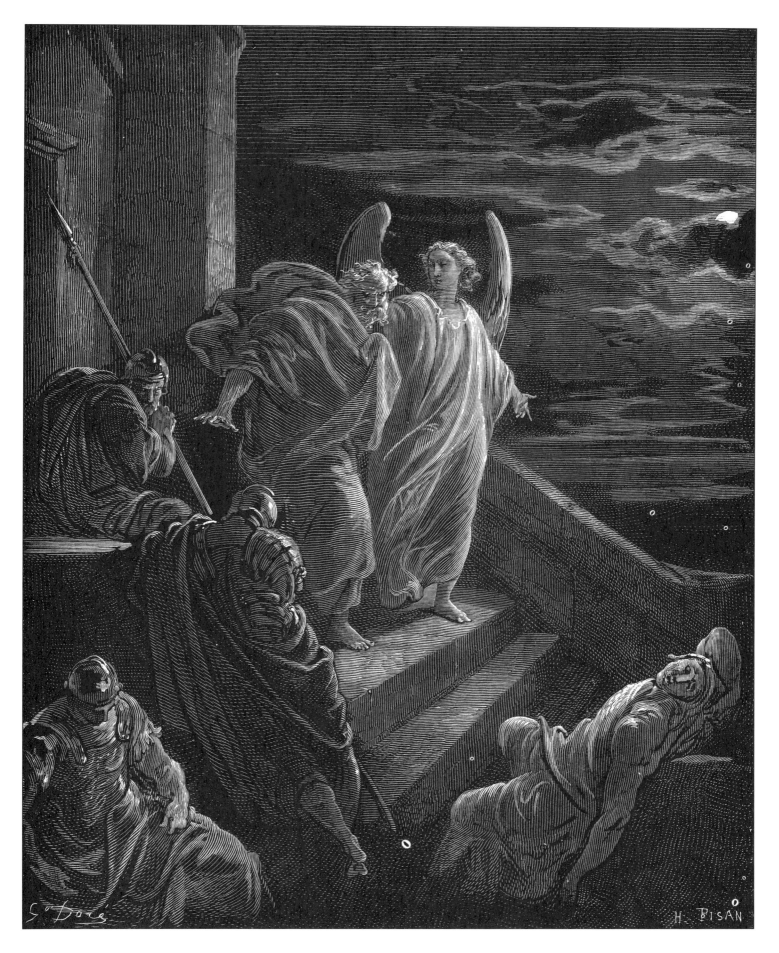

ST. PETER DELIVERED FROM PRISON

And, behold, the angel of the Lord came upon him, and a light shined in the prison: and he smote Peter on the side, and raised him up, saying, Arise up quickly. And his chains fell off from his hands. . . . (Acts 12:7)

The Holy Bible | 15

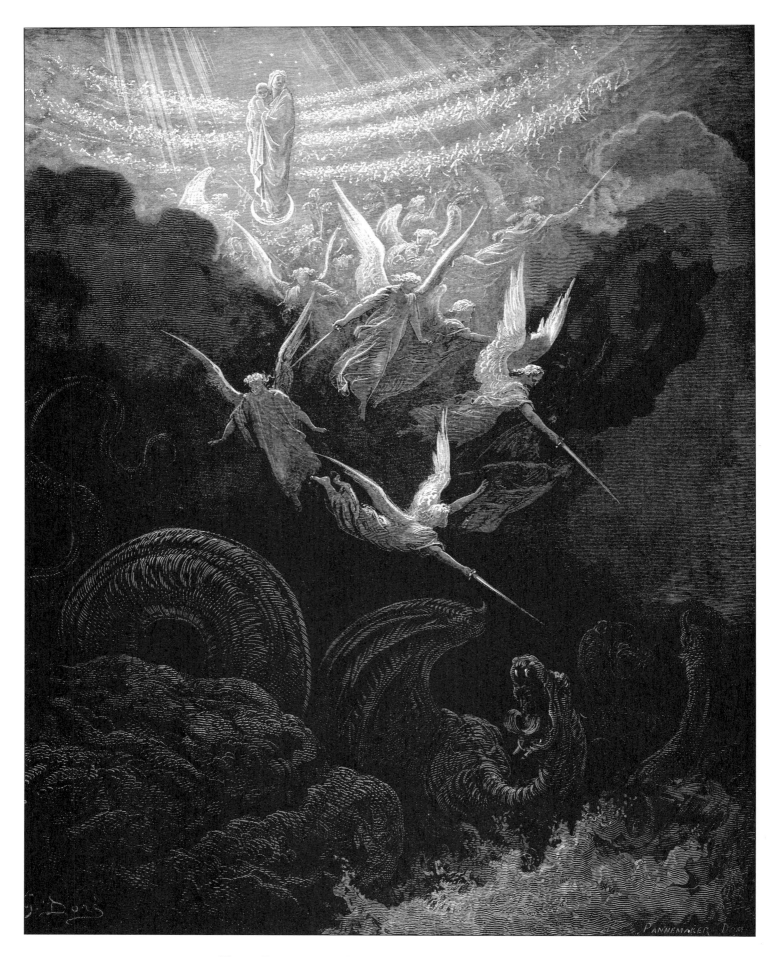

THE CROWNED VIRGIN: A VISION OF JOHN

And there appeared a great wonder in heaven; a woman clothed with the sun, and the moon under
her feet, and upon her head a crown of twelve stars. . . . (Revelations 12:1)

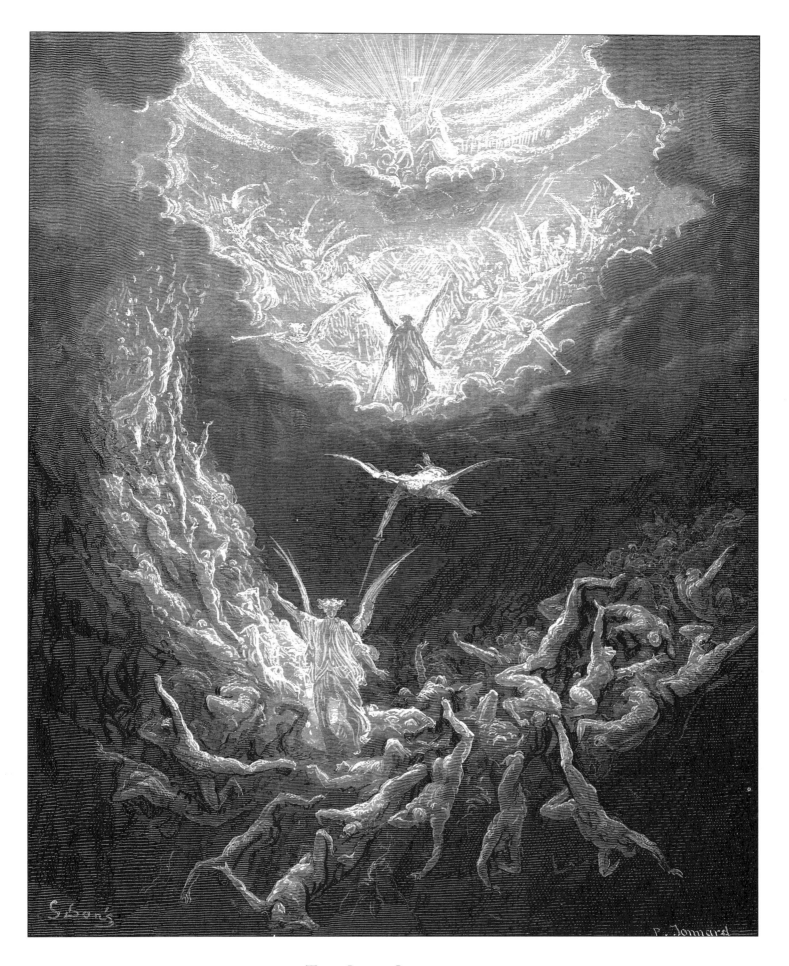

THE LAST JUDGMENT
And I saw the dead, small and great, stand before God; and the books were opened: and another
book was opened, which is the book of life. . . . (Revelation 20:12)

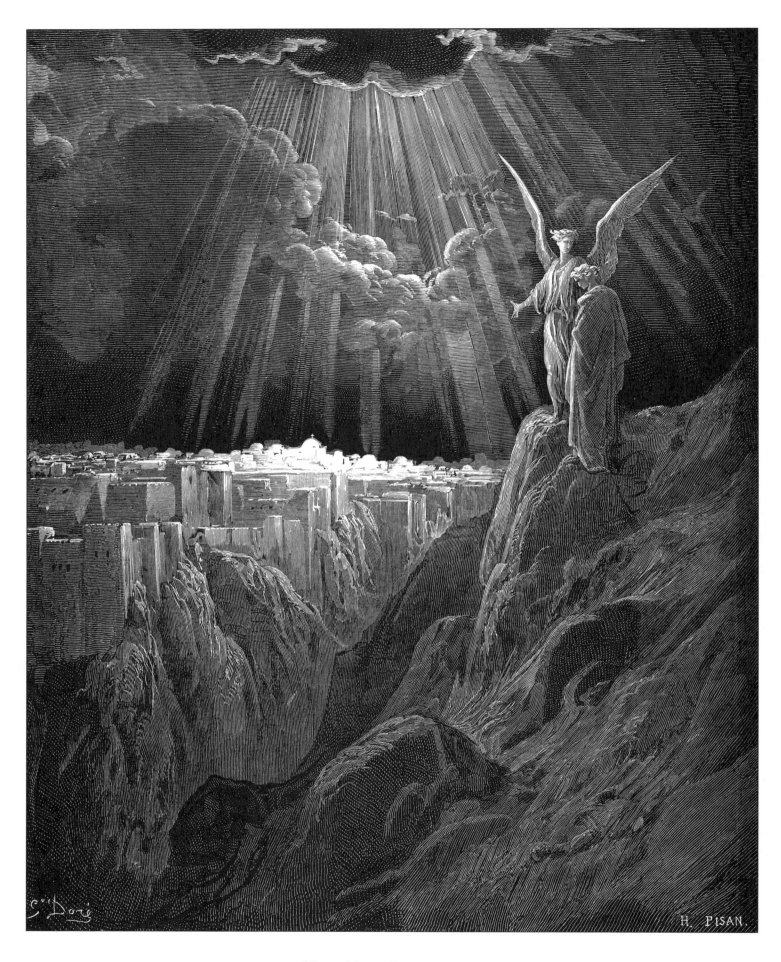

THE NEW JERUSALEM
And I John saw the holy city, new Jerusalem, coming down from God out of heaven, prepared as
a bride adorned for her husband. . . . (Revelation 21:2)

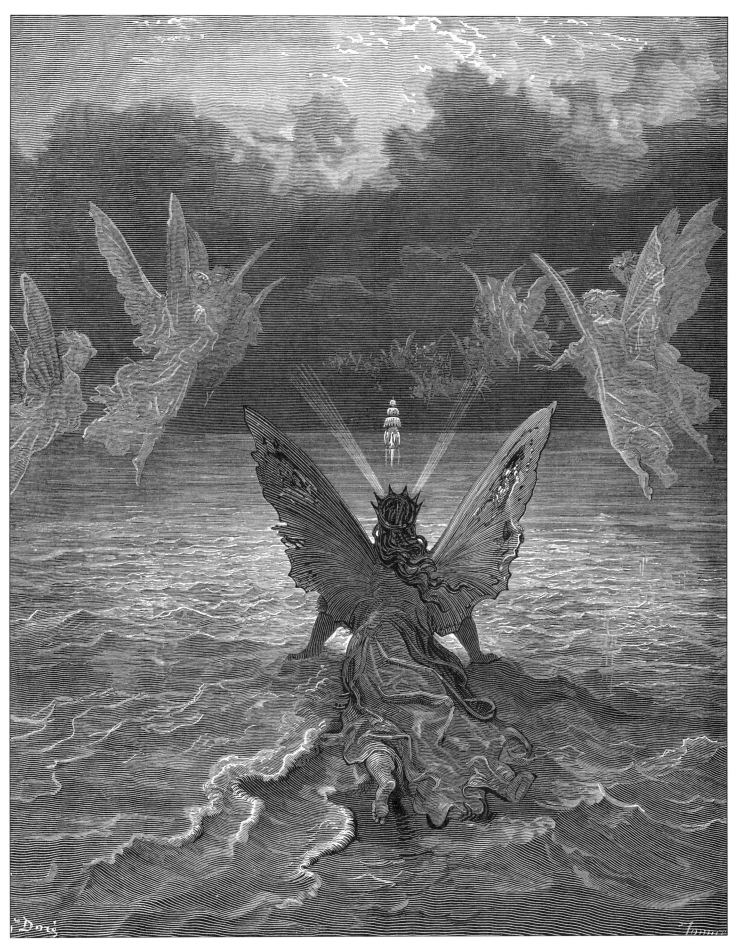

'Twas not those souls that fled in pain,
Which to their corses came again,
But a troop of spirits blest . . .

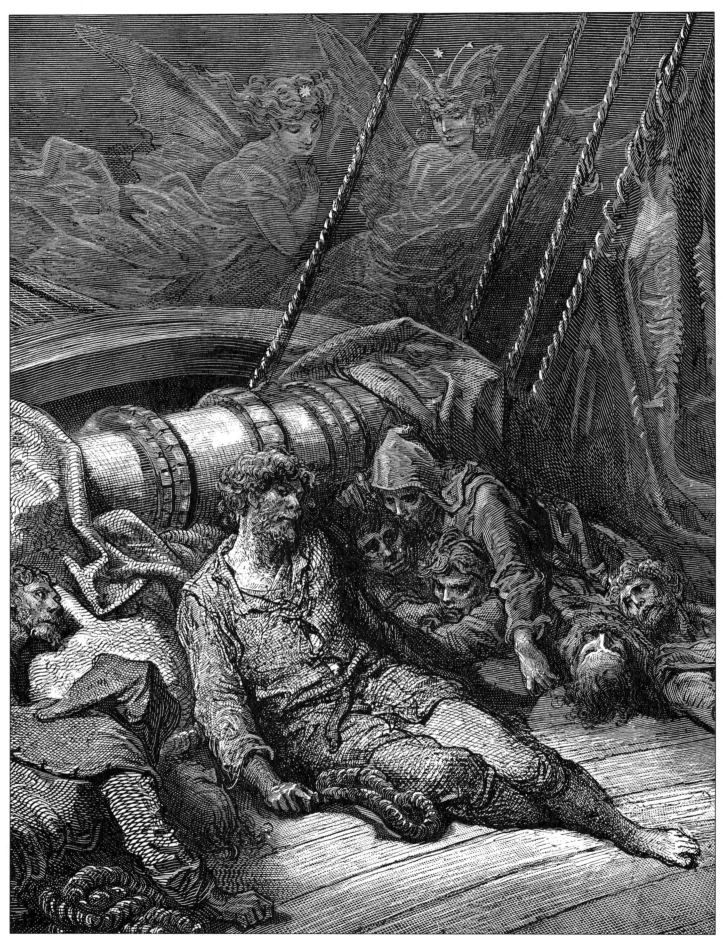

But ere my living life returned,
I heard, and in my soul discerned
Two voices in the air.

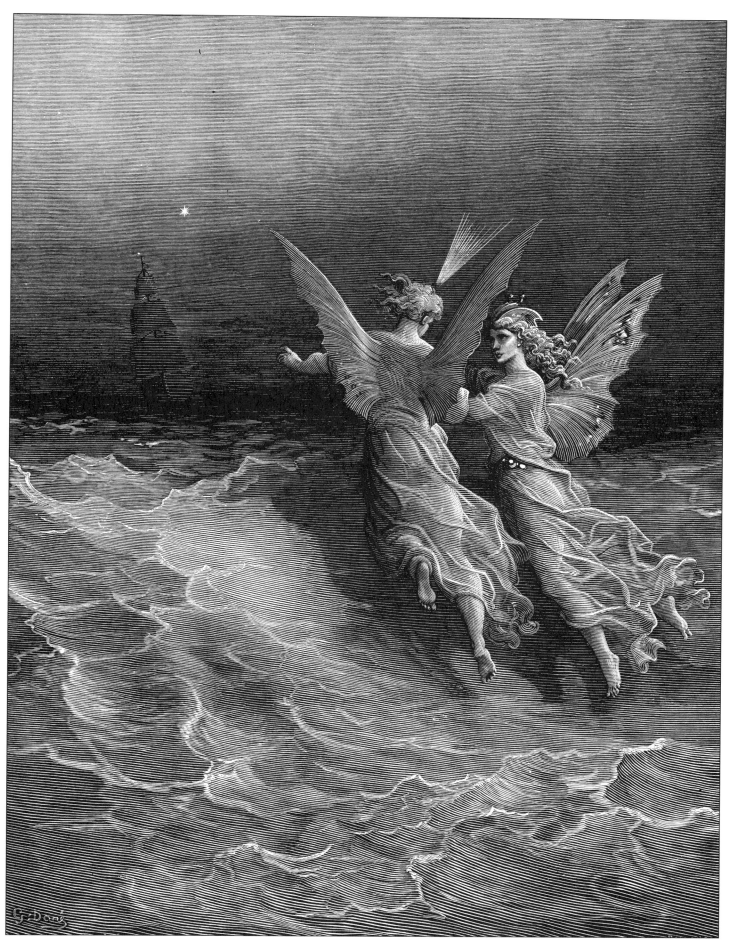

Fly, brother, fly! more high, more high!
Or we shall be belated:
For slow and slow that ship will go,
When the Mariner's trance is abated.

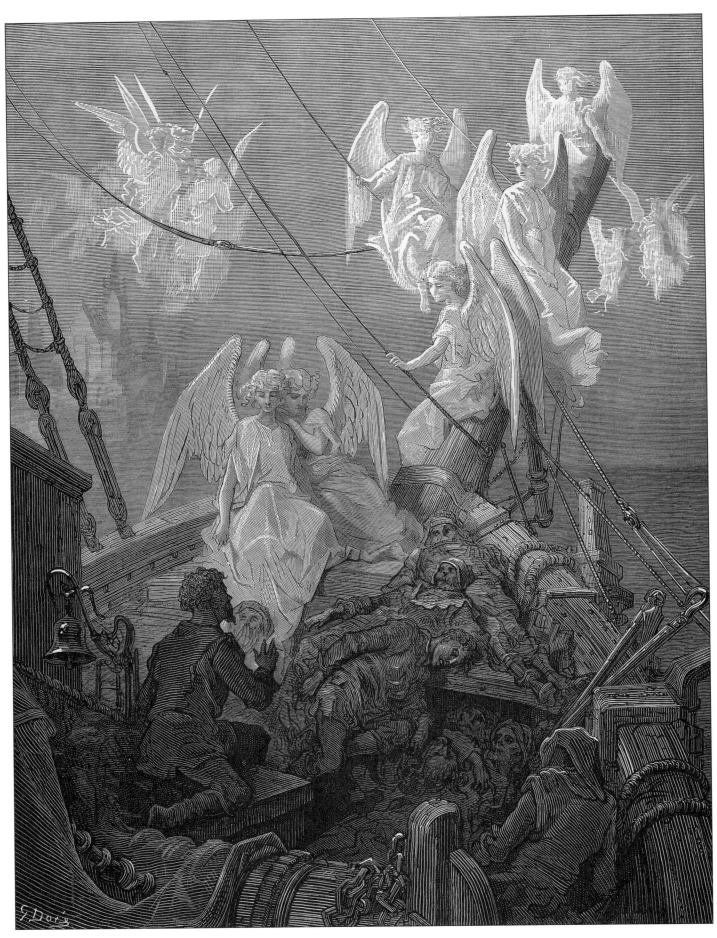

This seraph-band, each waved his hand:
It was a heavenly sight!
They stood as signals to the land,
Each one a lovely light . . .

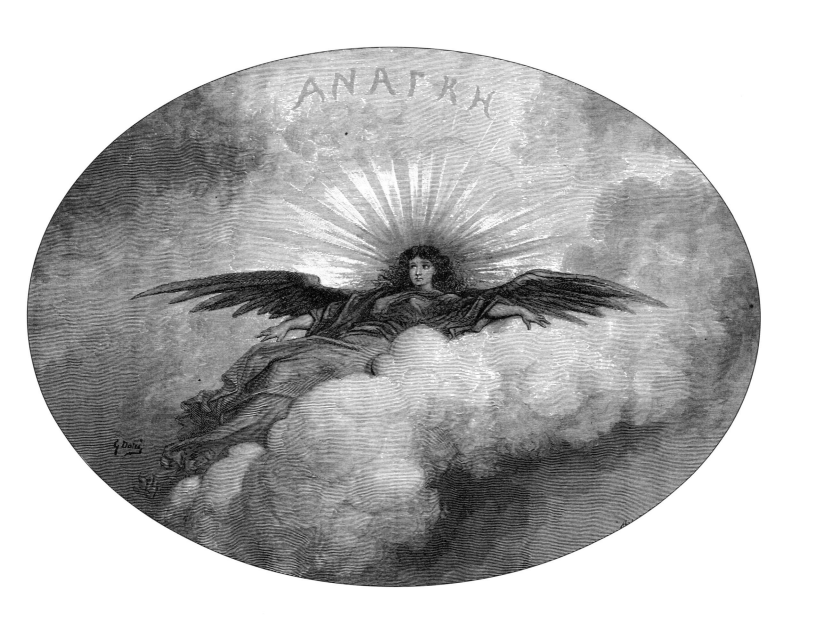

ΑΝΑΓΚΗ (Inevitability)

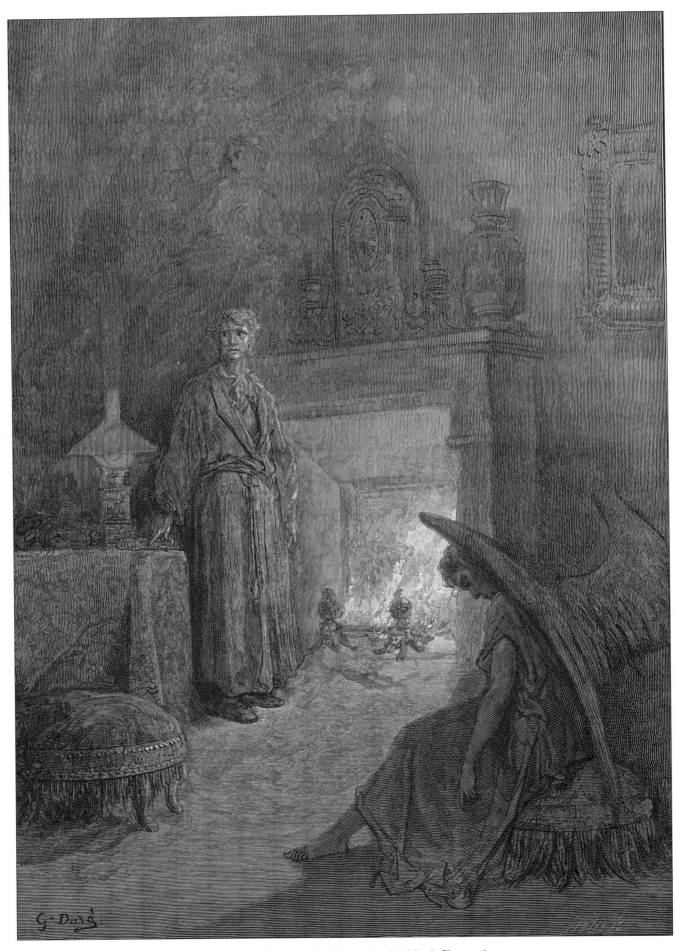

Ah, distinctly I remember it was in the bleak December;
And each separate dying ember wrought its ghost upon the floor.

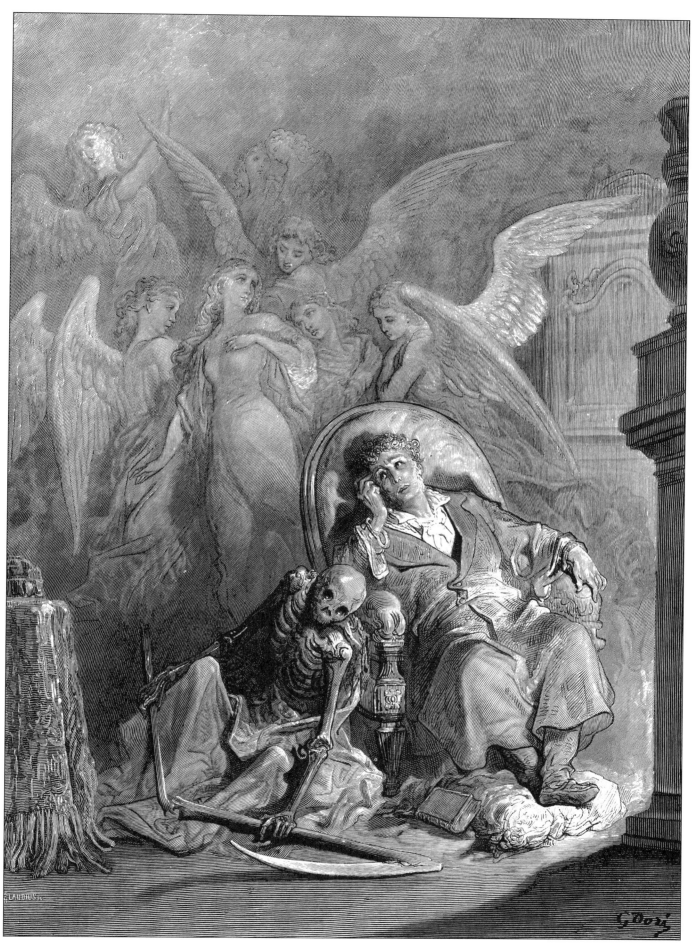

Eagerly I wished the morrow;—vainly I had sought to borrow
From my books surcease of sorrow—sorrow for the lost Lenore—

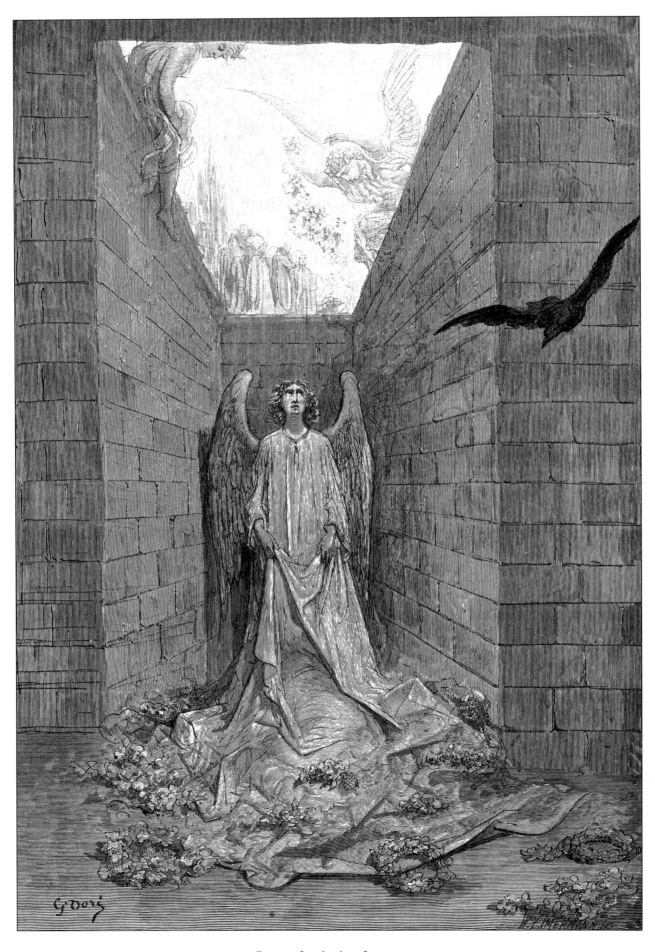

Sorrow for the lost Lenore

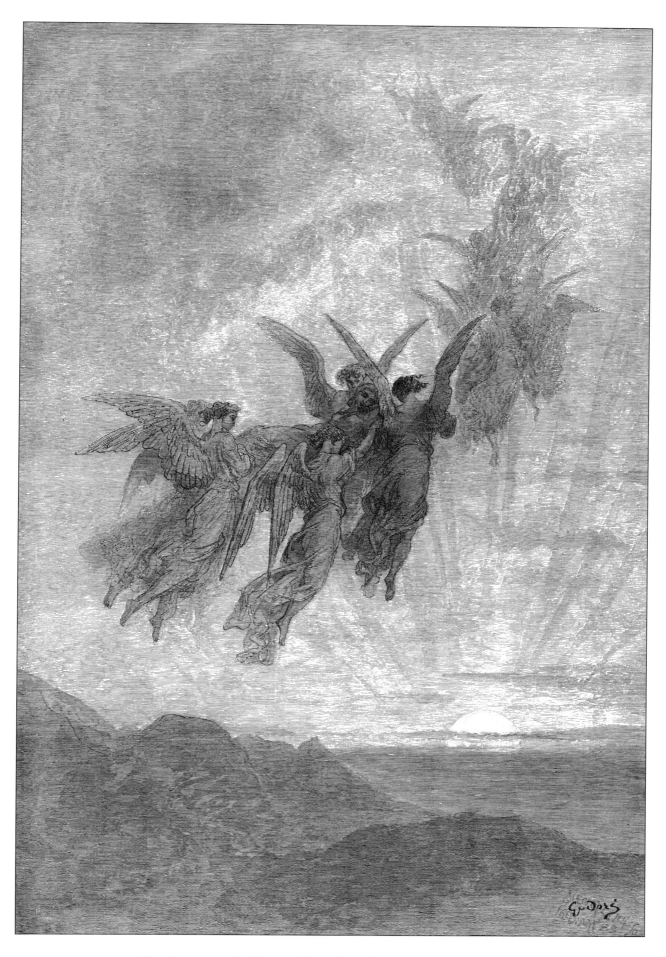

For the rare and radiant maiden whom the angels name Lenore—
Nameless *here* for evermore.

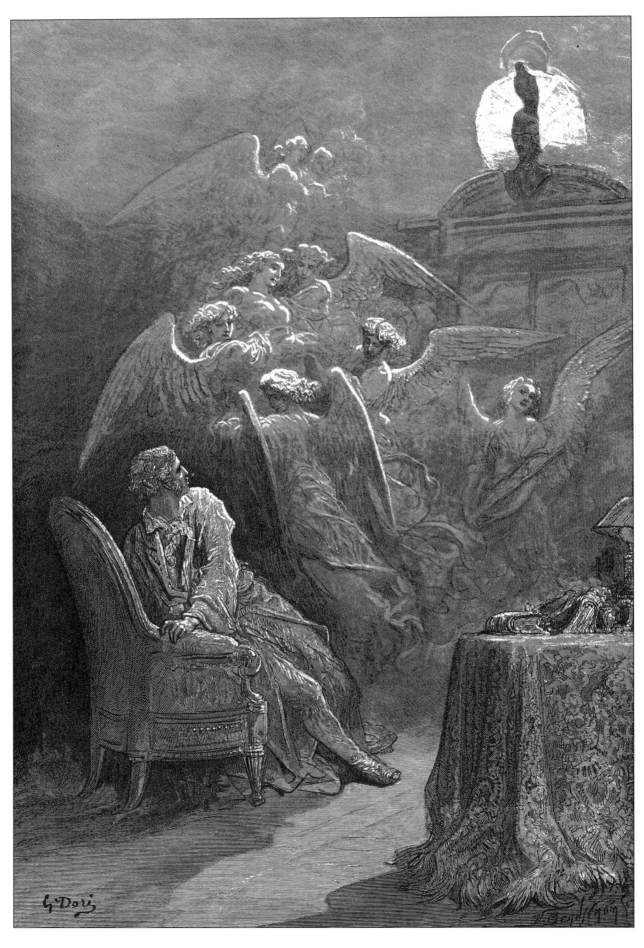

"Wretch," I cried, "thy God hath lent thee—by these angels he hath sent thee
Respite—respite and nepenthe from thy memories of Lenore; . . ."

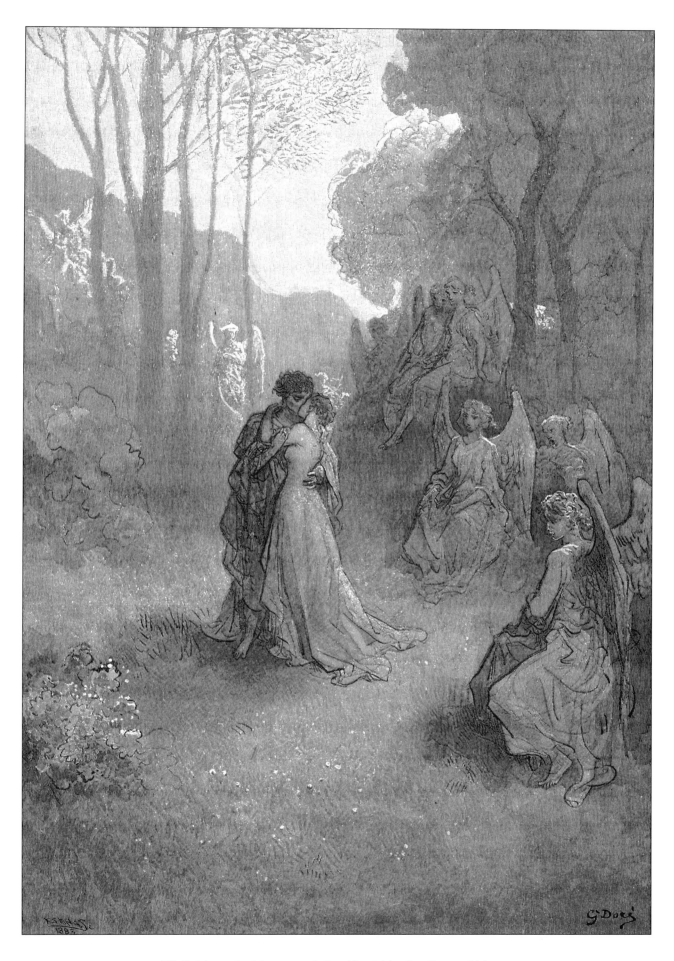

"Tell this soul with sorrow laden if, within the distant Aidenn,
It shall clasp a sainted maiden whom the angels name Lenore—"

The Raven | *29*

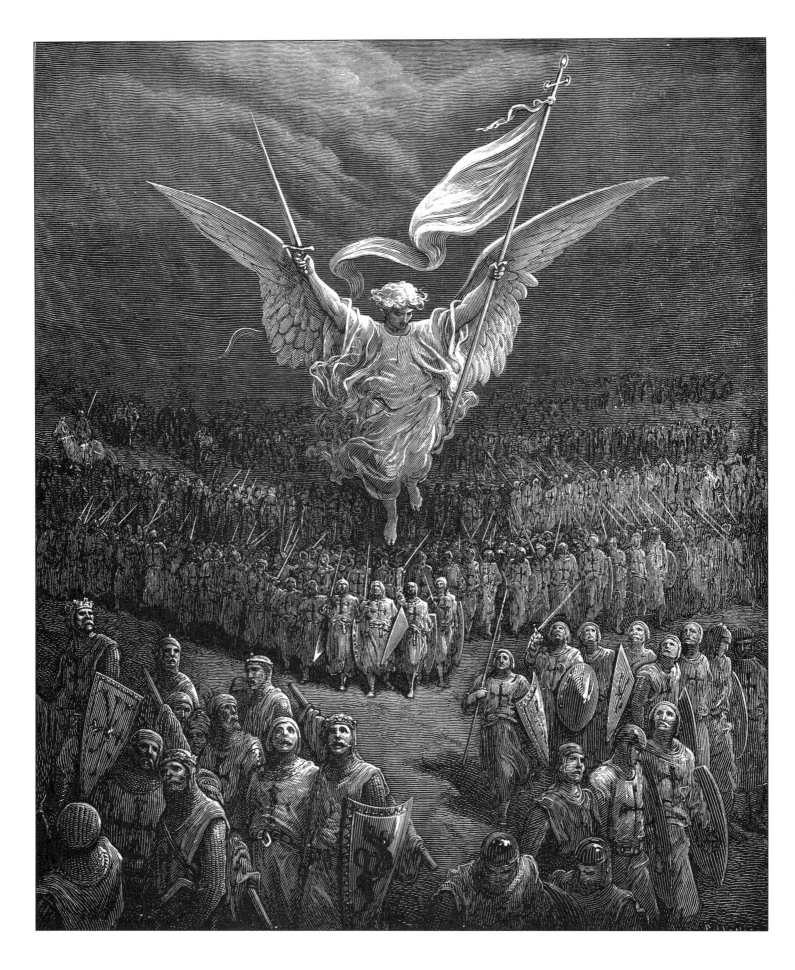

THE ROAD TO JERUSALEM
A luminous angel guides the Crusaders marching at night

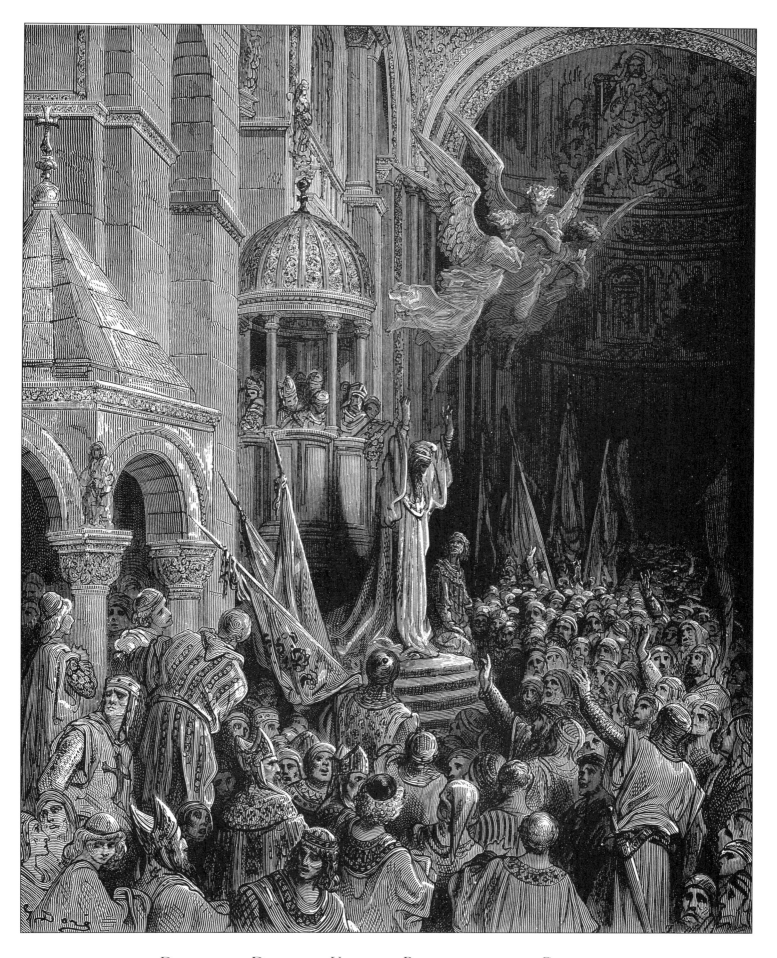

DANDOLO, DOGE OF VENICE, PREACHING THE CRUSADE
Dandolo, the astute ninety-year-old doge of Venice, promises to supply ships and provisions
for a low fee in exchange for half of all eastern conquests

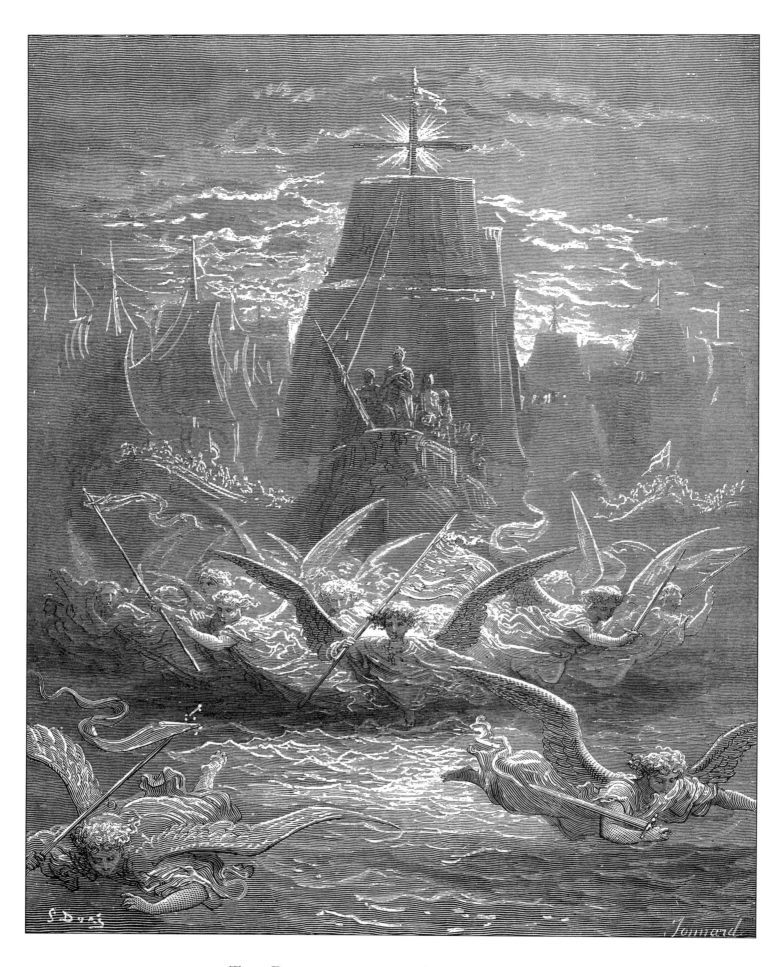

THE DEPARTURE FROM AIGUES-MORTES
The Crusaders, led by King Charles of Anjou and St. Louis, set out to convert the emir of Tunis

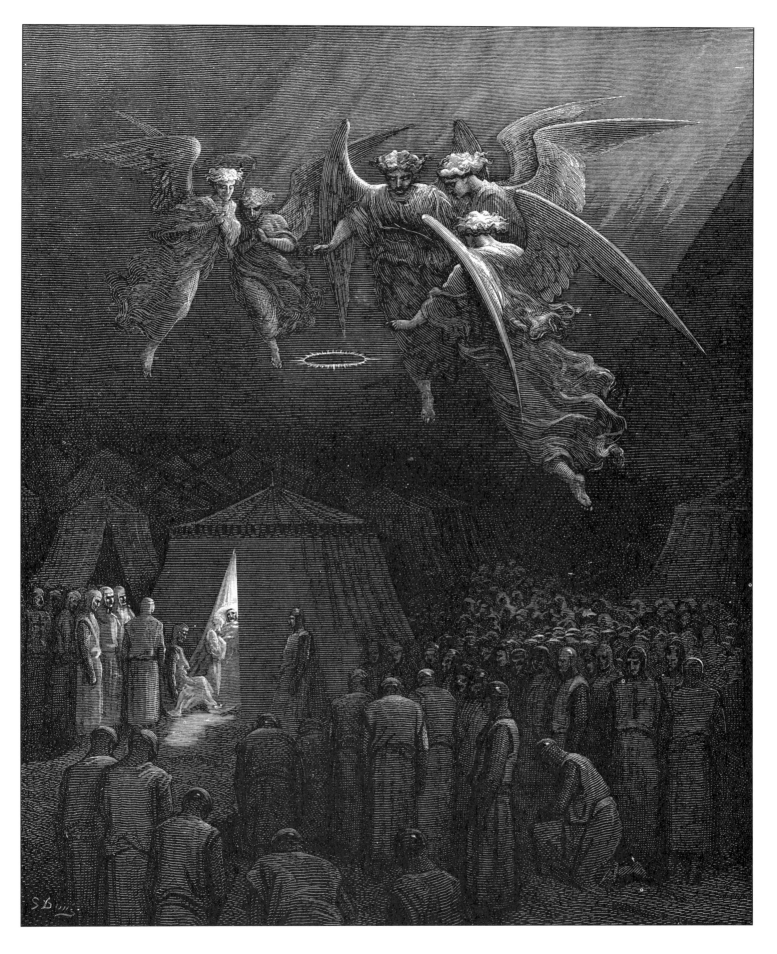

THE NIGHT OF AUGUST 25, 1270
At the death of St. Louis, the French soldiers mourn for their dynamic leader

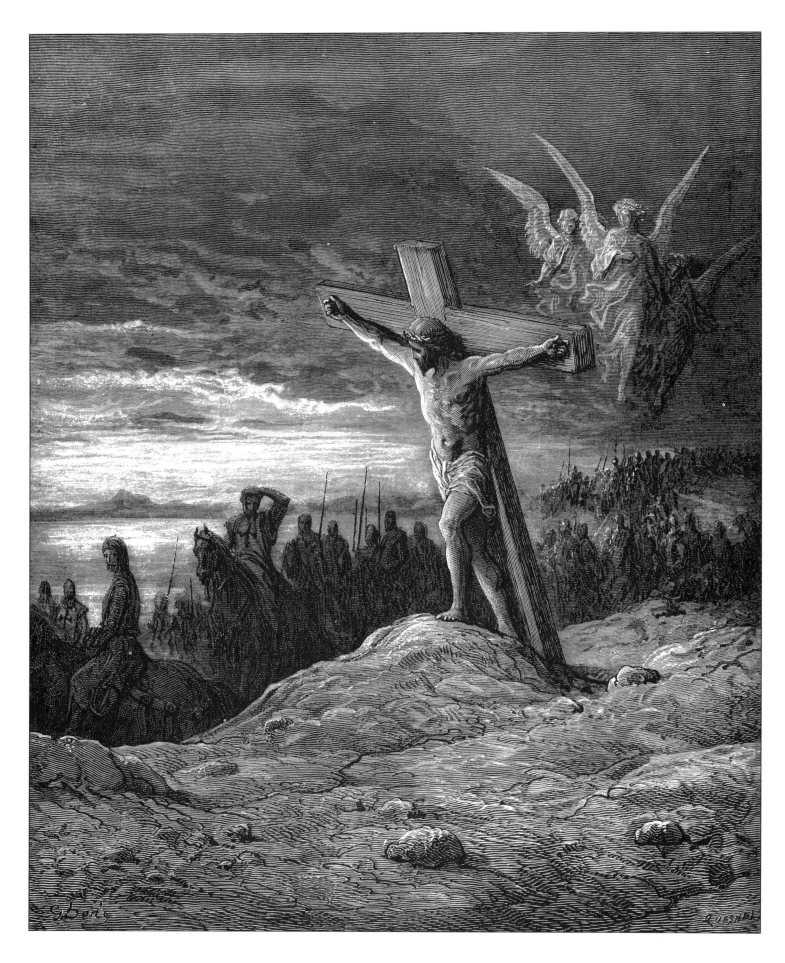

MIRACLES
The Crusaders witness an extraordinary event on their sacred journey

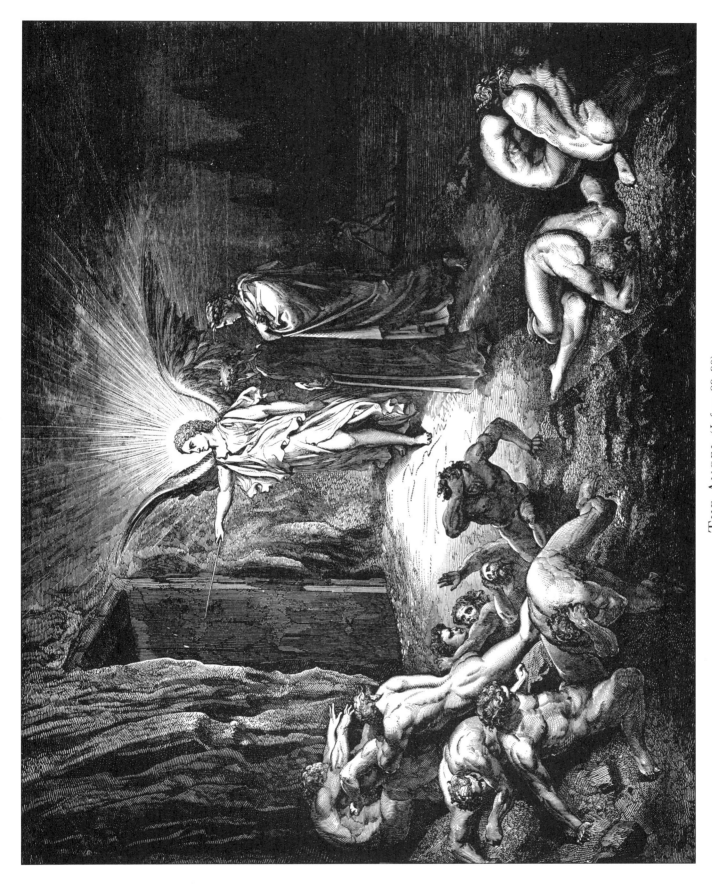

THE ANGEL (*Inf.* IX. 89, 90)
He reached the gate, and with a little rod
He opened it, for there was no resistance

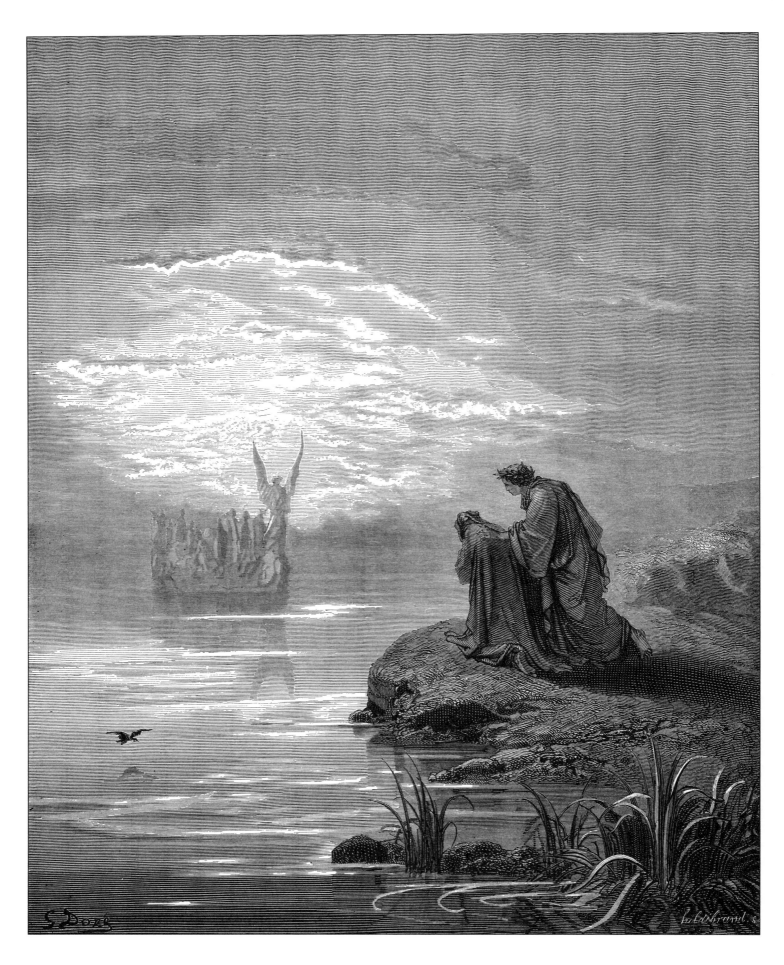

THE VESSEL (*Purg.* II. 27–29)
But when he clearly recognized the pilot,
He cried: "Make haste, make haste to bow the knee!
Behold the angel of God!"

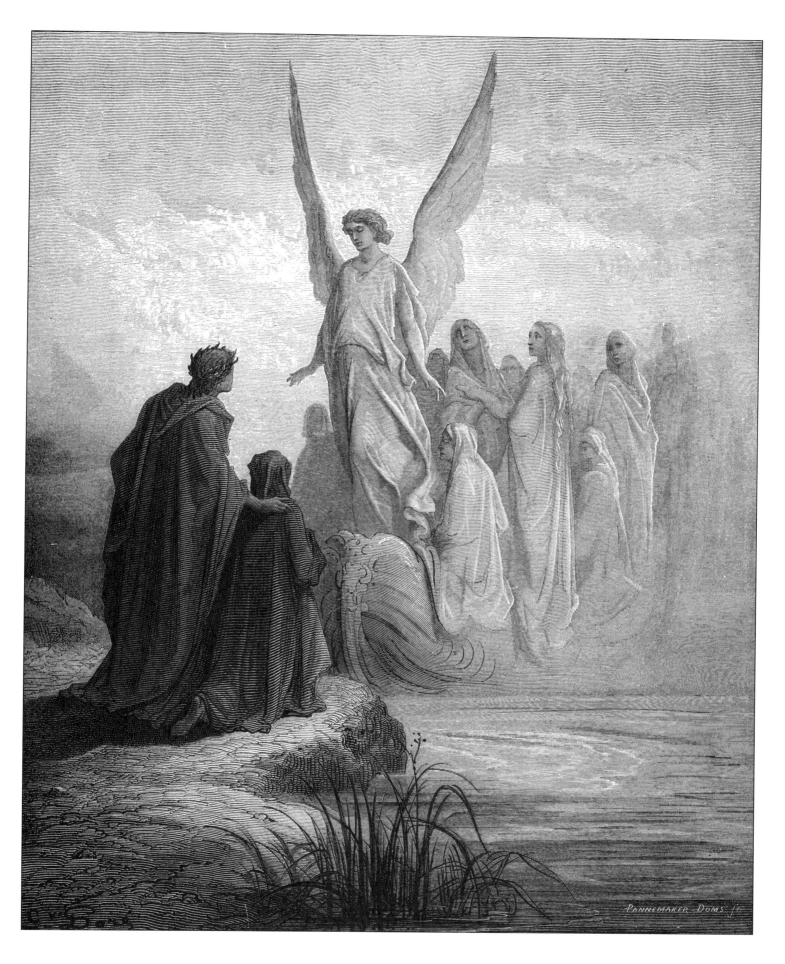

THE CELESTIAL PILOT (*Purg.* II. 44)
Beatitude seemed written in his face

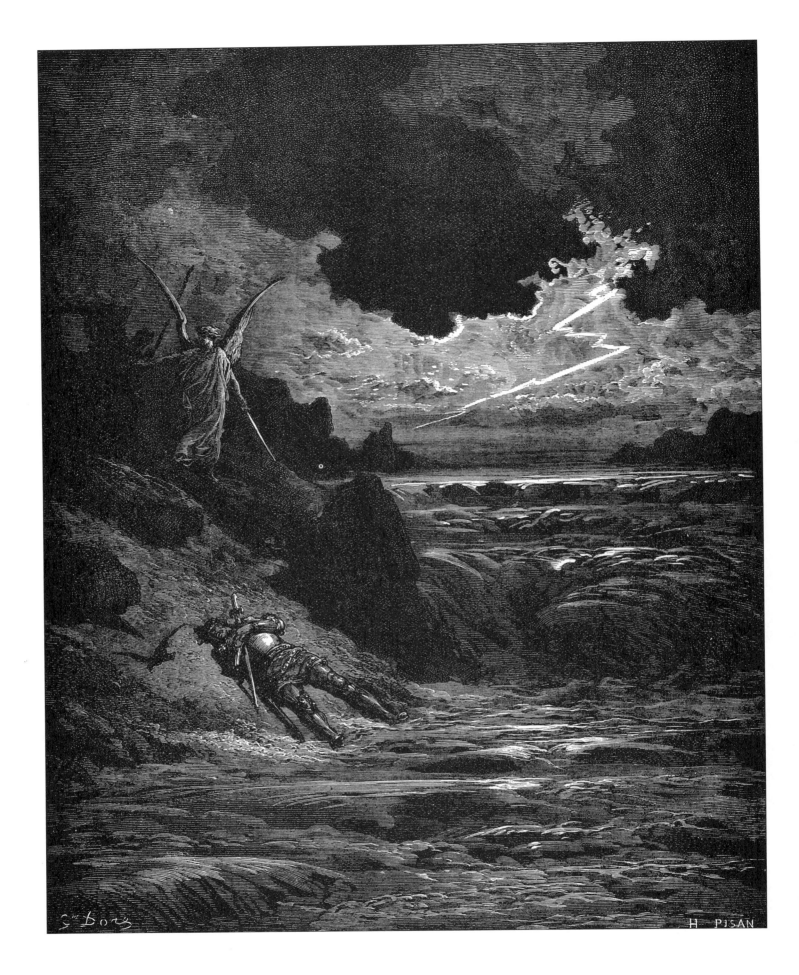

BUONCONTE DA MONTEFELTRO (*Purg.* v. 104, 105)
"God's Angel took me up, and he of hell
Shouted: 'O thou from heaven, why dost thou rob me?'"

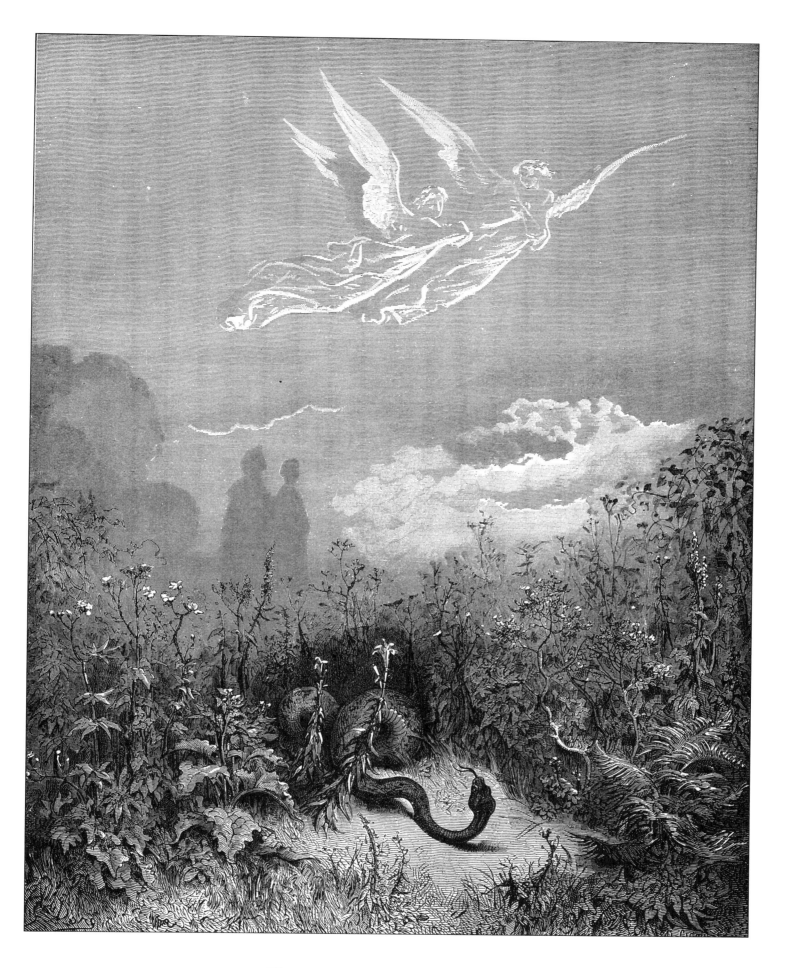

THE SERPENT (*Purg.* VIII. 106, 107)
Hearing the air cleft by their verdant wings,
The Serpent fled, and round the Angels wheeled

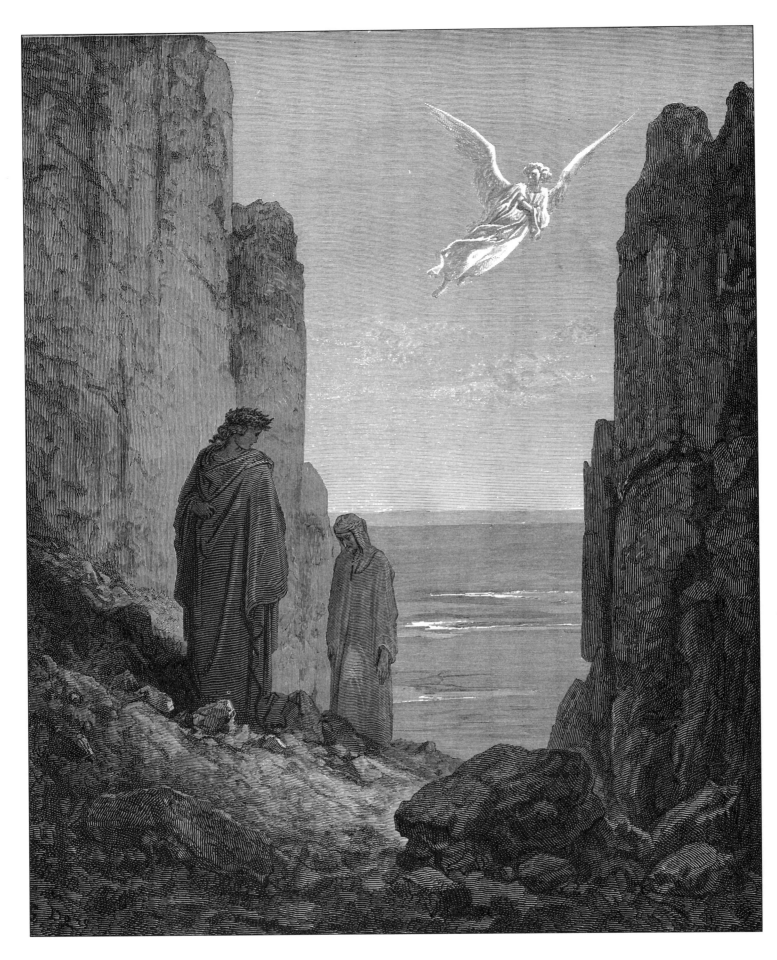

ASCENT TO THE FIFTH CIRCLE (*Purg.* XIX. 52–54)
"What aileth thee, that aye to earth thou gazest?"
To me my Guide began to say, we both
Somewhat beyond the Angel having mounted

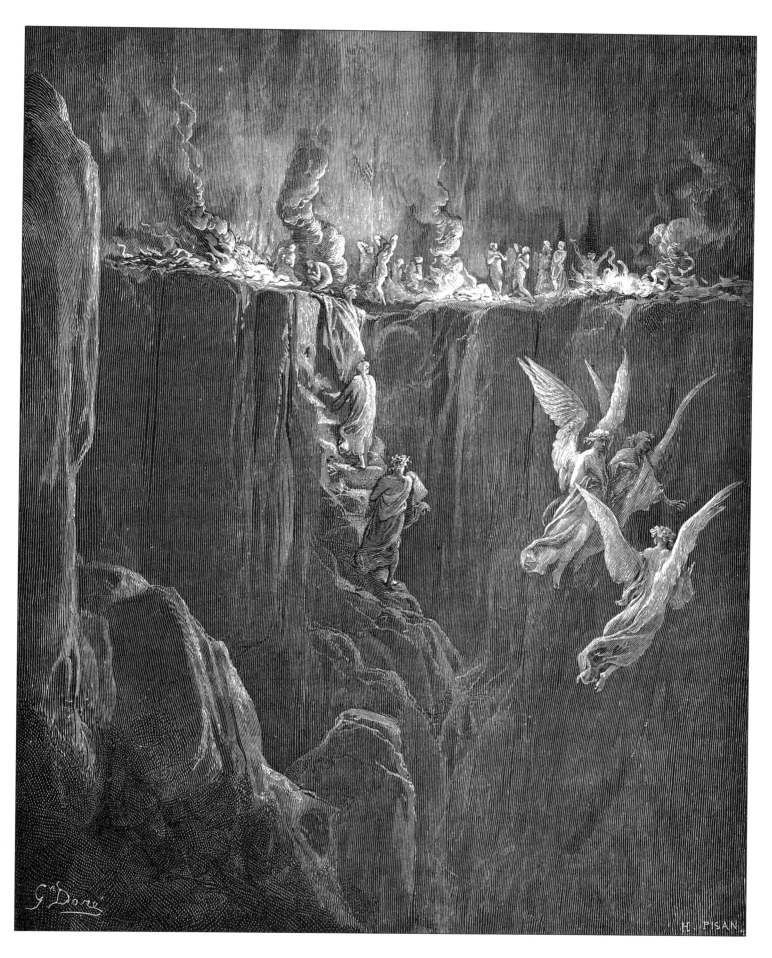

THE SEVENTH CIRCLE (*Purg.* XXV. 112–114)
There the enbankment shoots forth flames of fire,
And upward doth the cornice breath a blast
That drives them back, and from itself sequesters

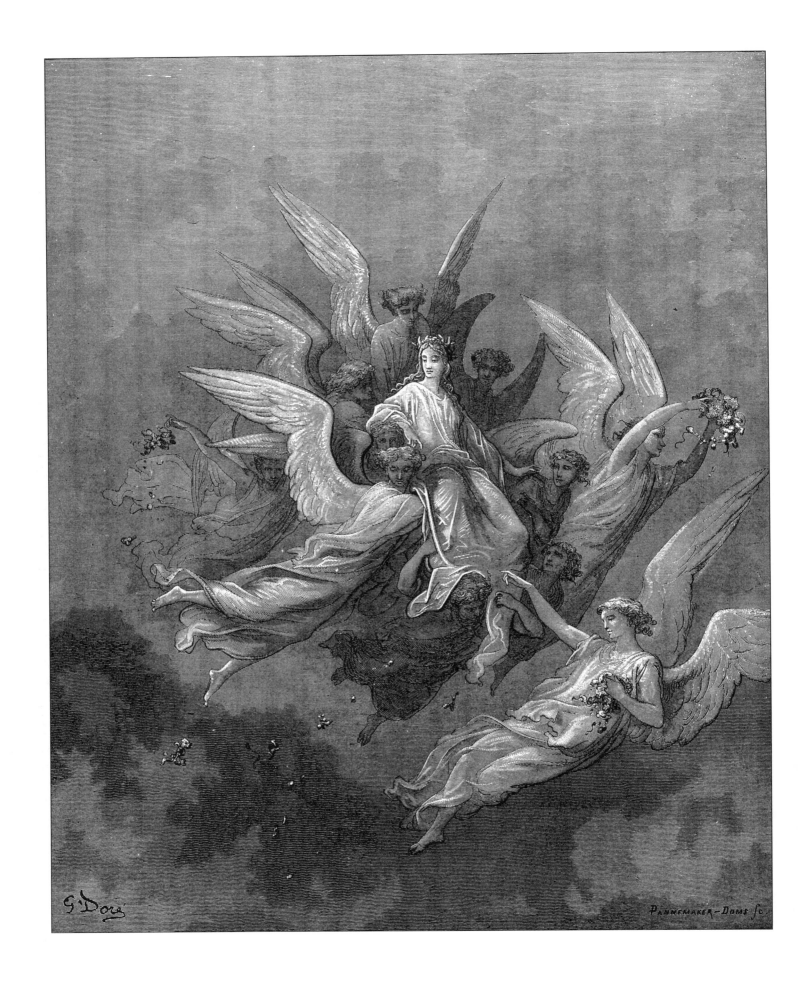

BEATRICE (*Purg.* XXX. 32, 33)
Appeared a lady under a green mantle,
Vested in color of the living flame

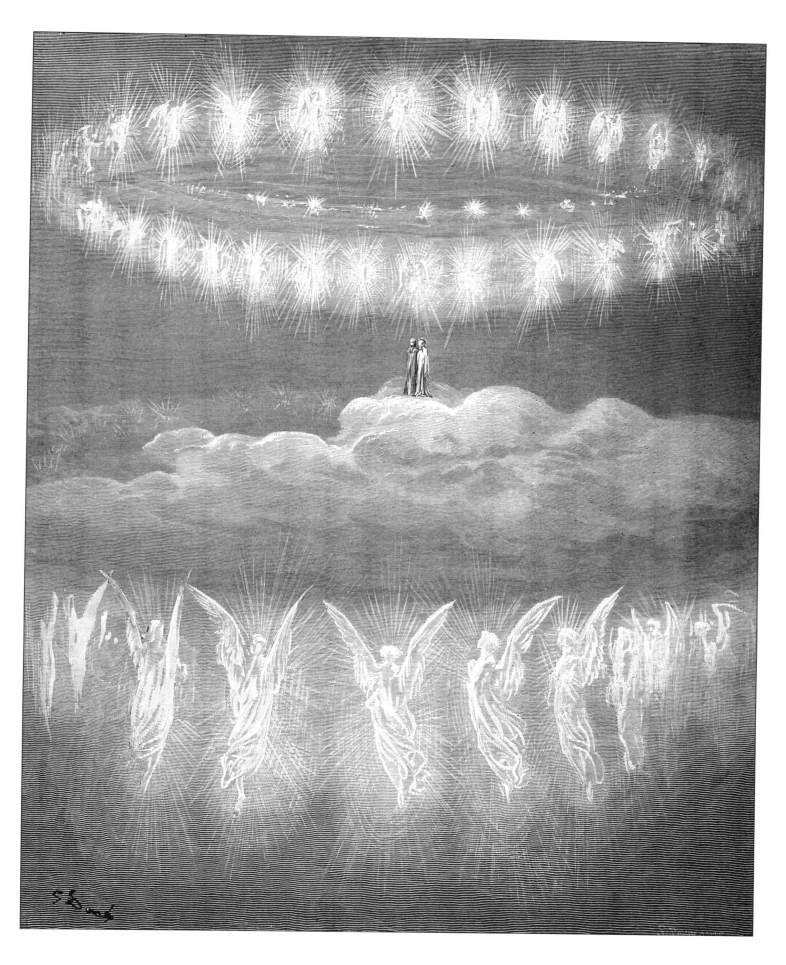

THE SUN—GLORIFIED SOULS (*Par.* XII. 19–21)
In such wise of those sempiternal roses
The garlands twain encompassed us about,
And thus the outer to the inner answered

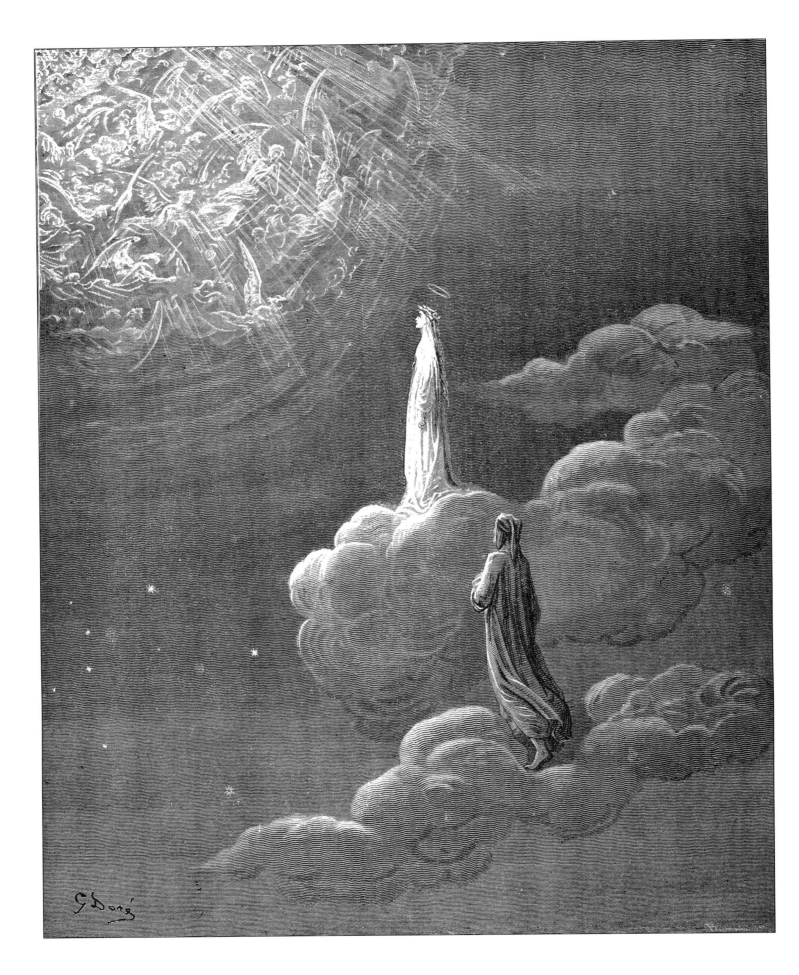

MARS (*Par.* XIV. 85–87)
Well was I ware that I was more uplifted
By the enkindled smiling of the star,
That seemed to me more ruddy than its wont

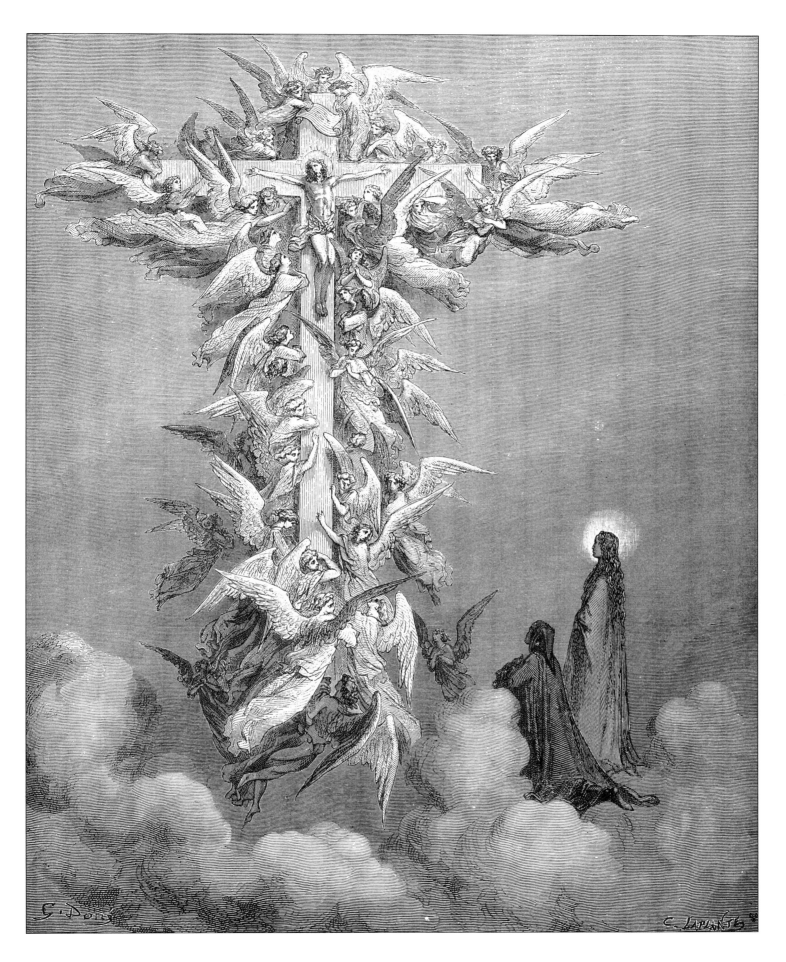

THE CROSS (*Par.* XIV. 103–105)
Here doth my memory overcome my genius;
For on that cross as levin gleamed forth Christ,
So that I cannot find ensample worthy

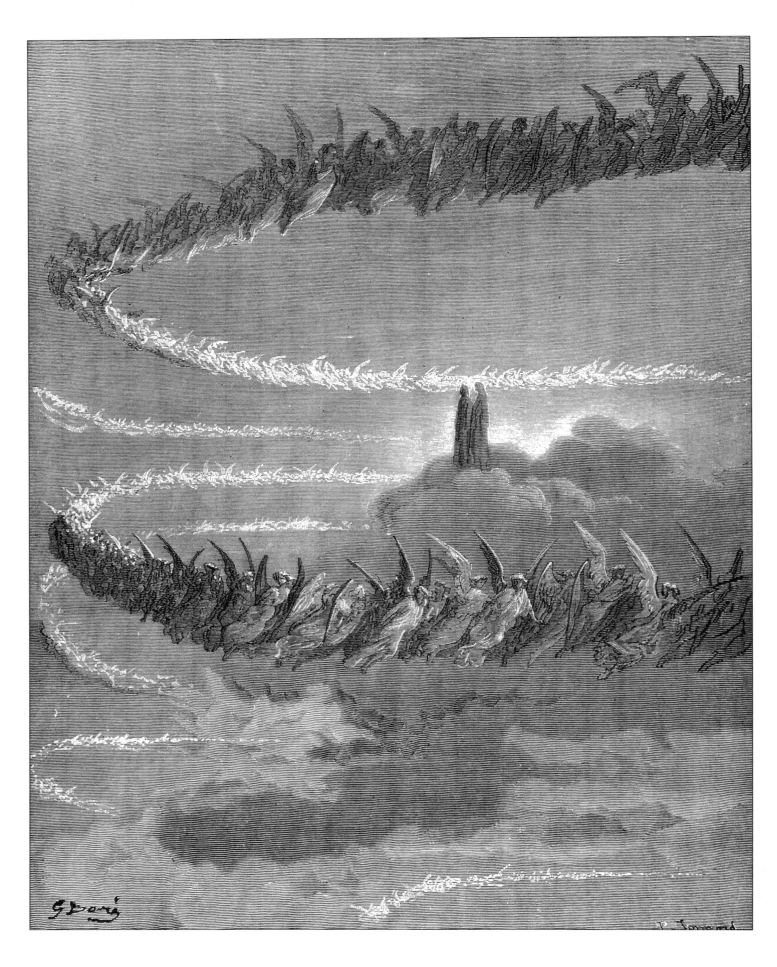

JUPITER (*Par.* XVIII. 76, 77)
The holy creatures
Sang flying to and fro

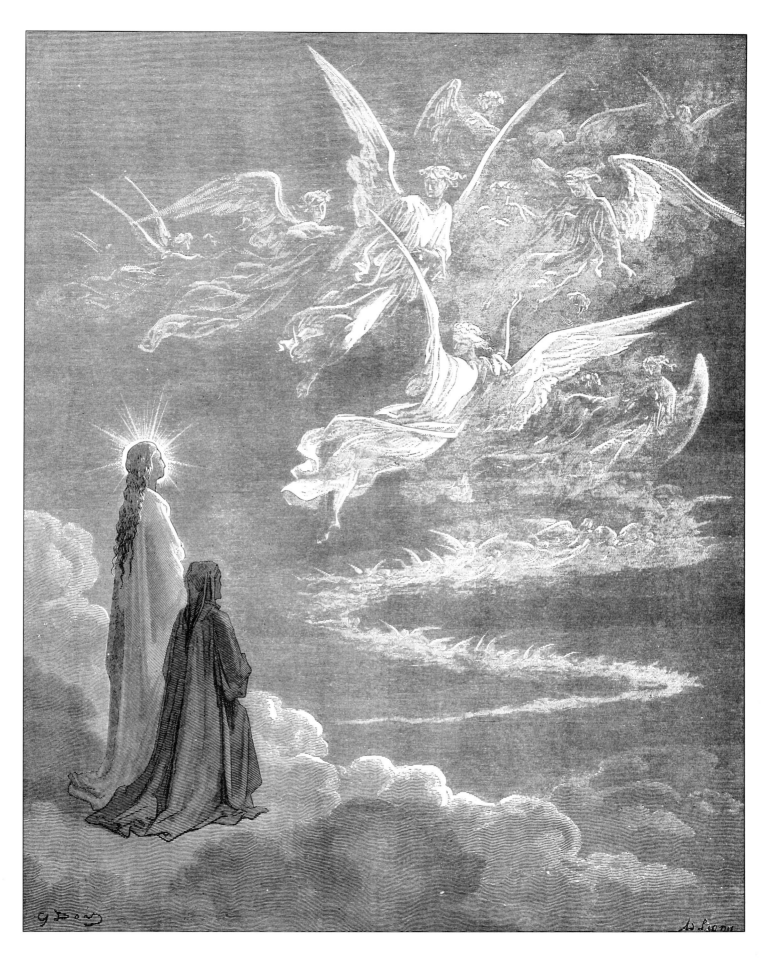

JUPITER (*Par.* XVIII. 124–126)
O soldiery of heaven, whom I contemplate,
Implore for those who are upon the earth
All gone astray after the bad example!

Divine Comedy / 47

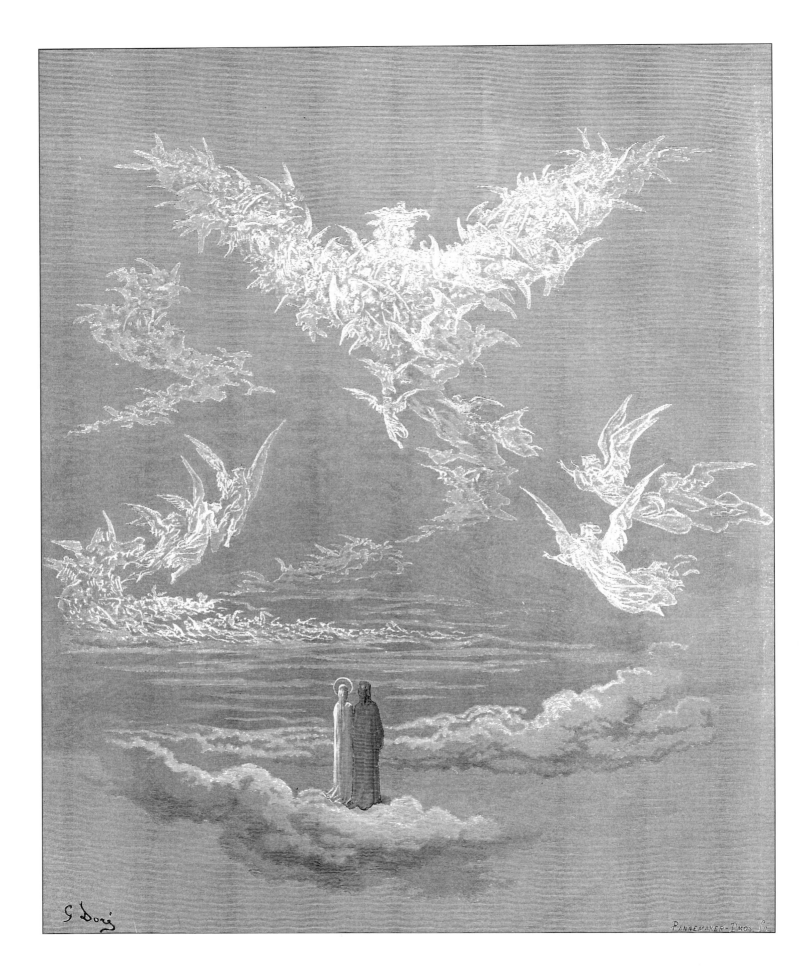

THE EAGLE (*Par.* XIX. 1–3)
Appeared before me with its wings outspread
The beautiful image that in sweet fruition
Made jubilant the interwoven souls

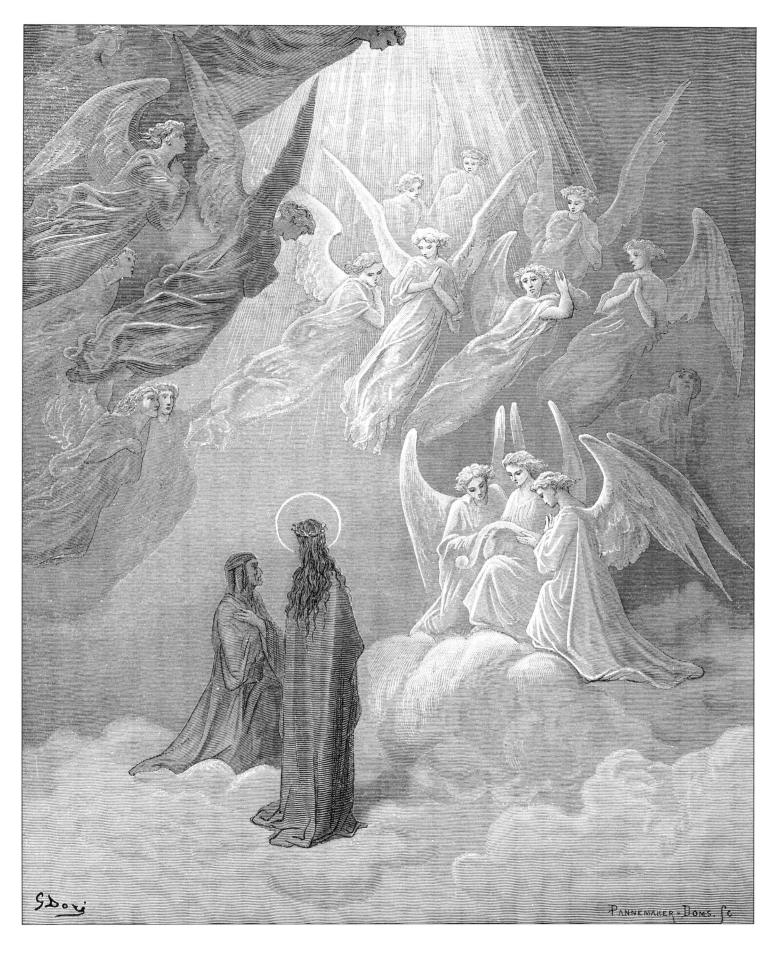

THE EAGLE (*Par.* XX. 10–12)
Those living luminaries all,
By far more luminous, did songs begin
Lapsing and falling from my memory

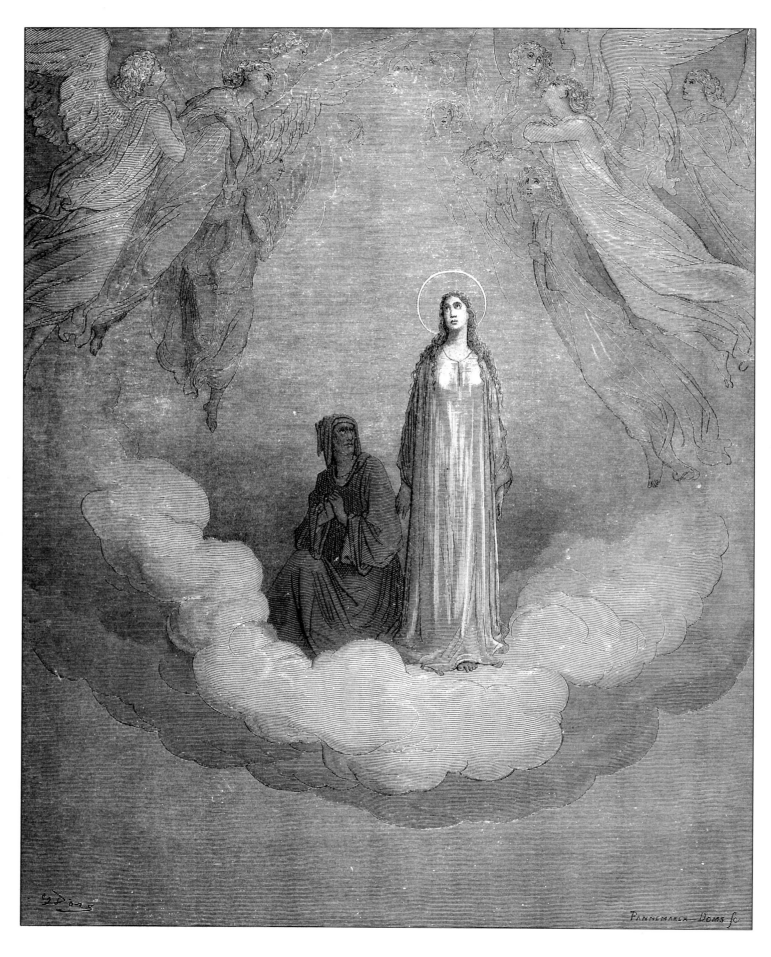

BEATRICE (*Par.* XXI. 1, 2)
Already on my Lady's face mine eyes
Again were fastened

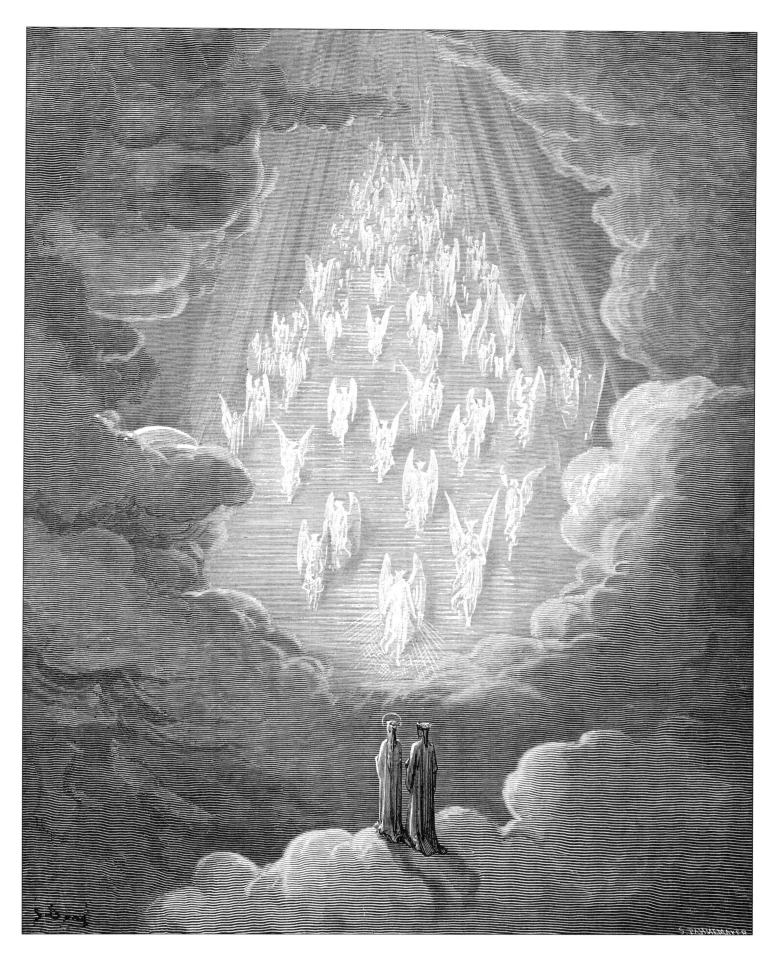

SATURN (*Par.* XXI. 29, 30)
A stairway I beheld to such height
Uplifted, that mine eye pursued it not

Divine Comedy | 51

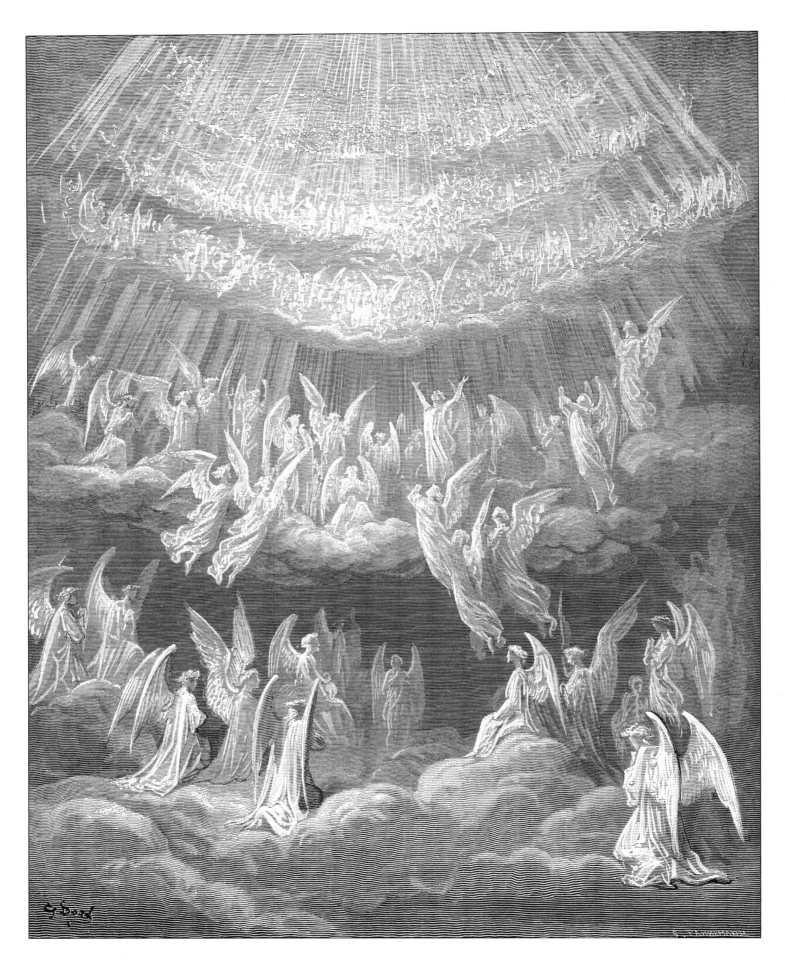

THE HEAVEN OF THE FIXED STARS (*Par.* XXVII. 1–3)
"Glory be to the Father, to the Son,
And Holy Ghost!" all Paradise began,
So that the melody inebriate made me

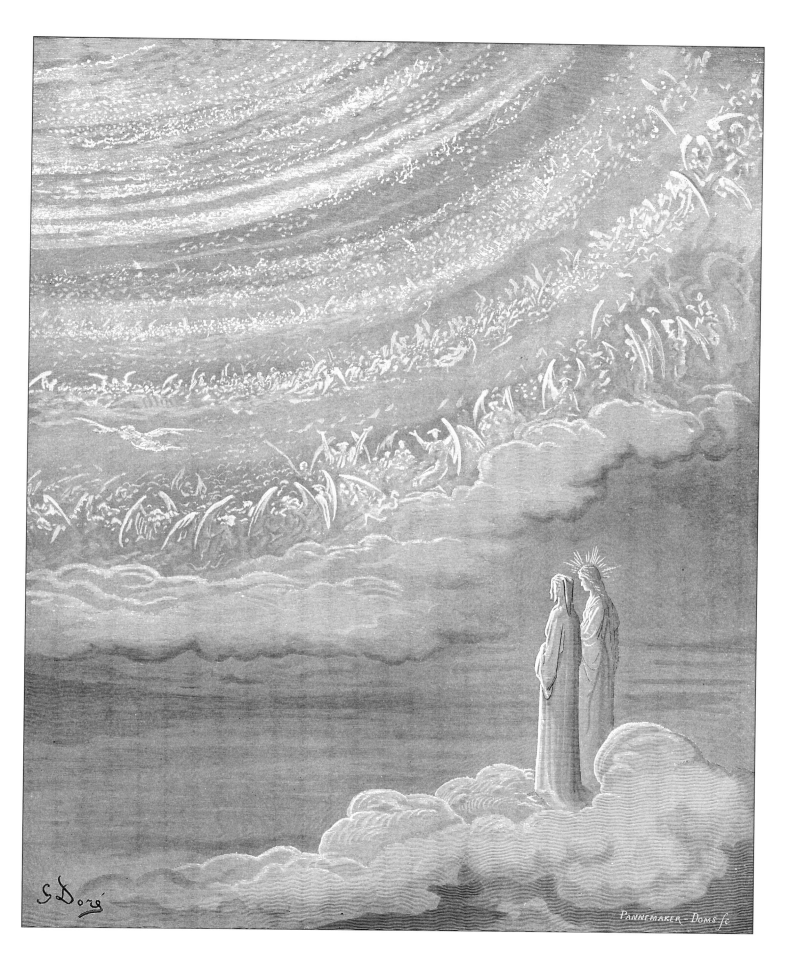

CRYSTALLINE HEAVEN (*Par.* XXVIII. 89, 90)
Not otherwise does iron scintillate
When molten, than those circles scintillated

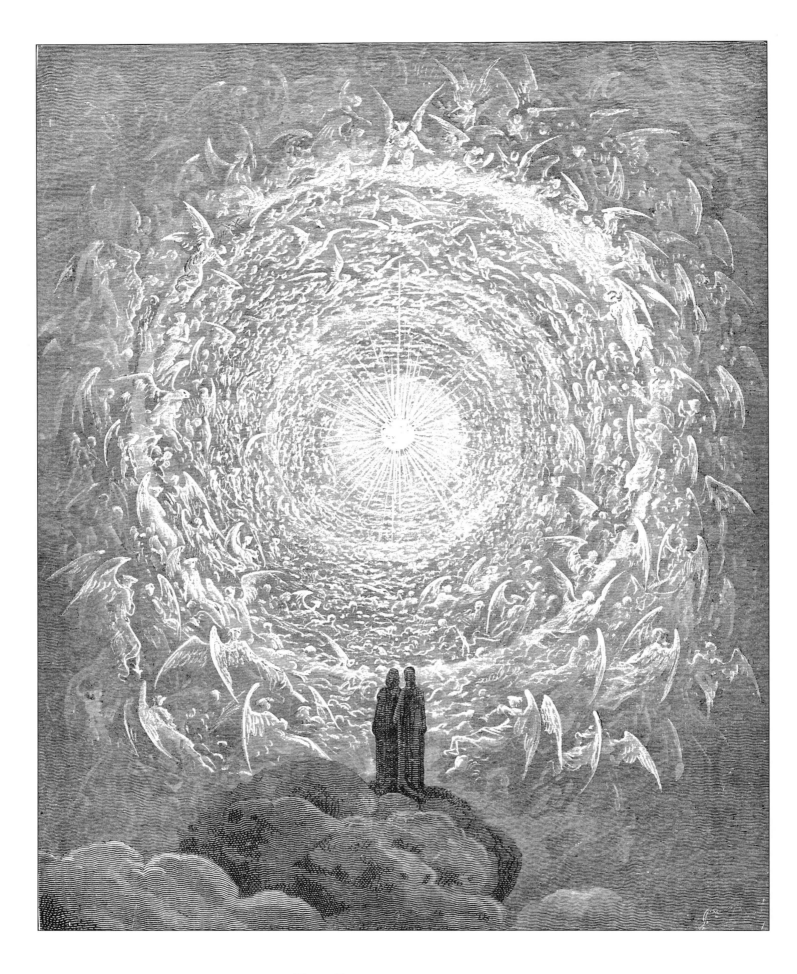

THE EMPYREAN (*Par.* XXXI. 1, 2)
In fashion then as of a snow-white rose
Displayed itself to me the saintly host

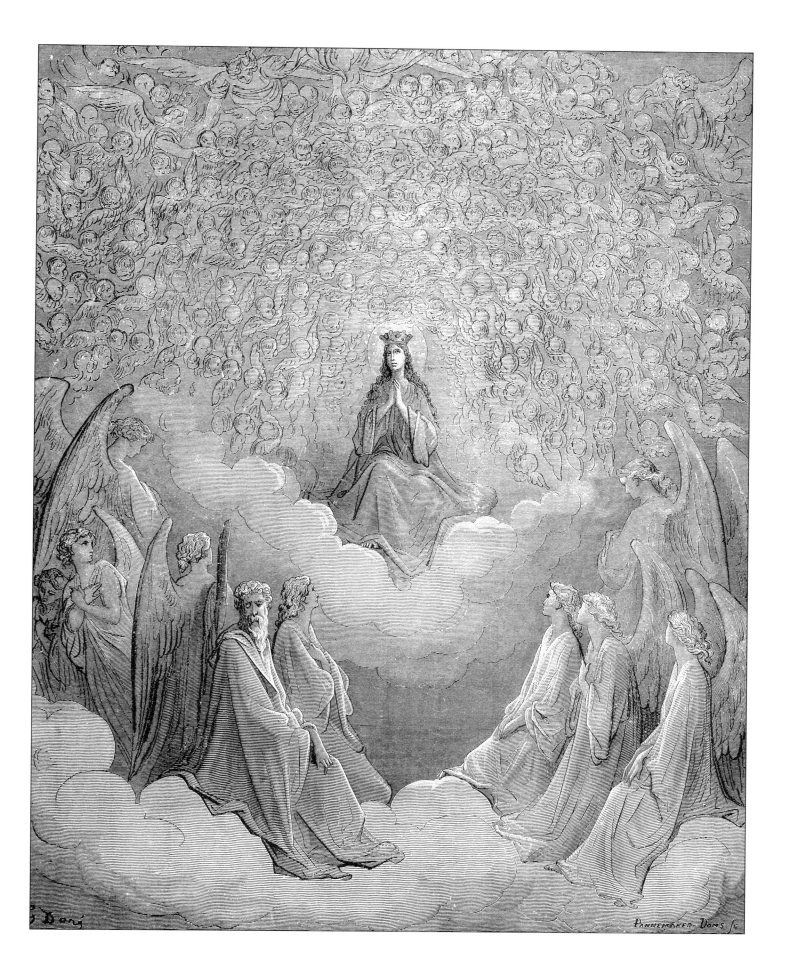

THE QUEEN OF HEAVEN (*Par.* XXXI. 116, 117)
"Thou shalt behold enthroned the Queen
To whom this realm is subject and devoted"

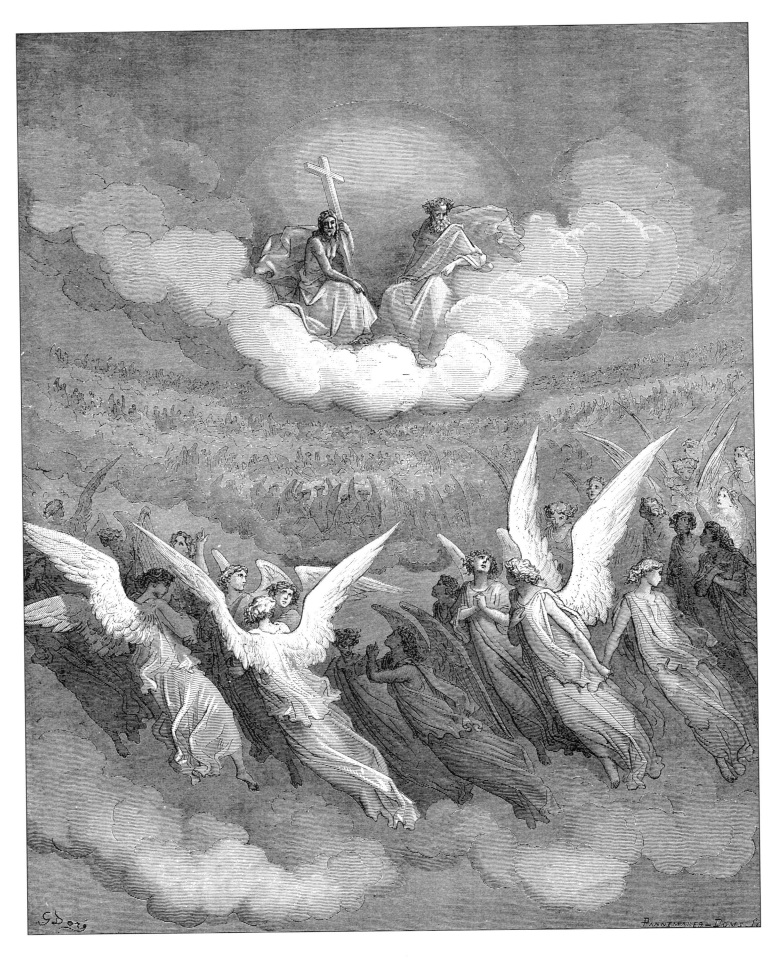

Heaven rung
With jubilee, and loud hosannas filled
The eternal regions
(III. 347–349)

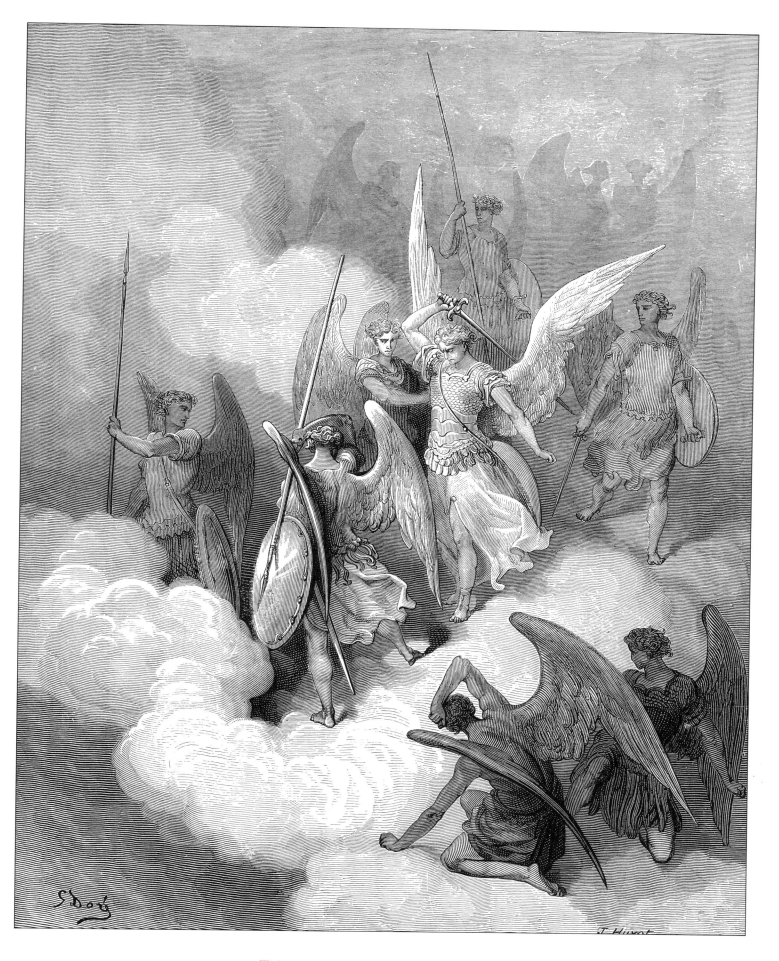

This greeting on thy impious crest receive
(VI. 188)

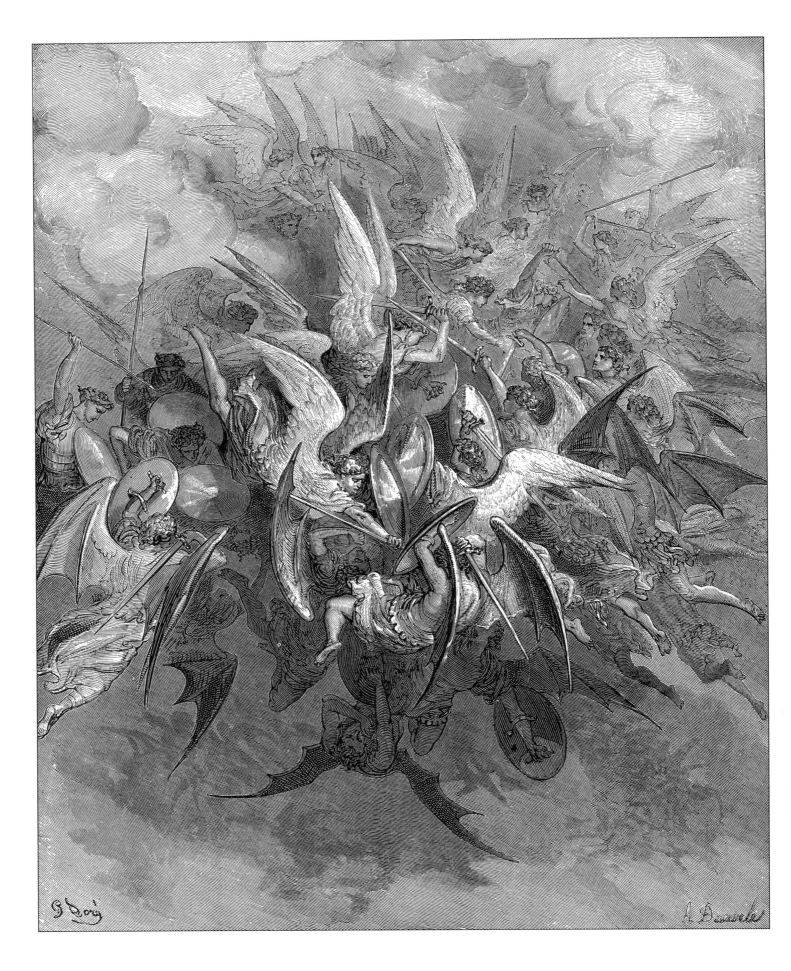

Now storming fury rose,
And clamour, such as heard in heaven till now
Was never
(VI. 207–209)

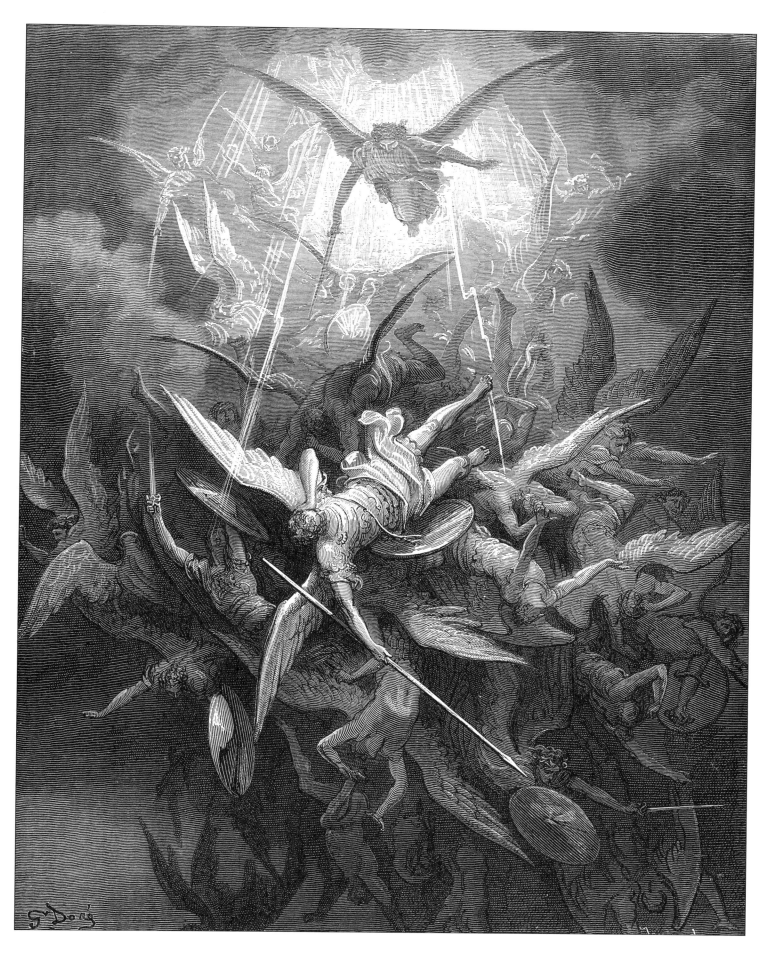

Him the Almighty Power
Hurled headlong flaming from the ethereal sky
(I. 44, 45)

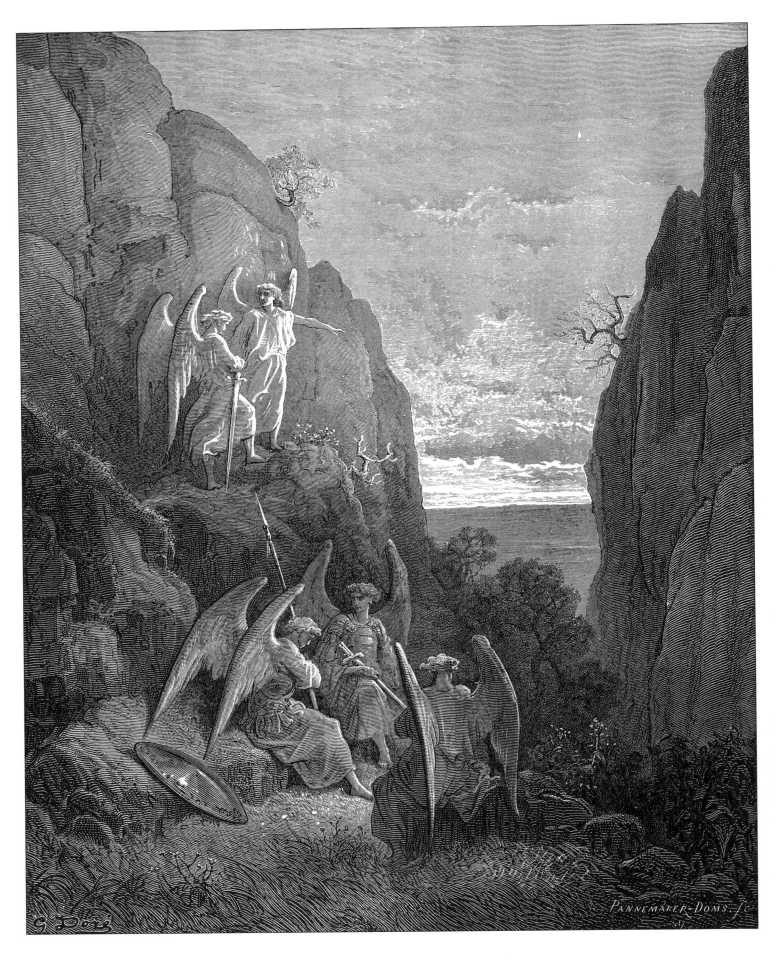

So promised he; and Uriel to his charge
Returned
(IV. 589, 590)

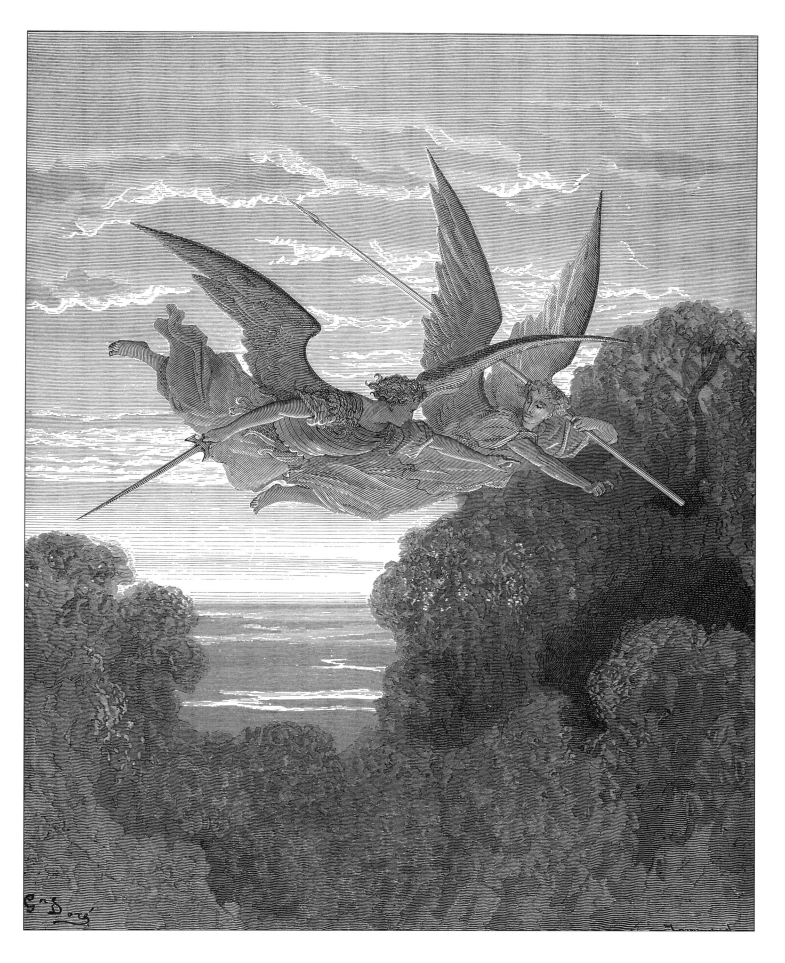

These to the bower direct
In search of whom they sought
(IV. 798, 799)

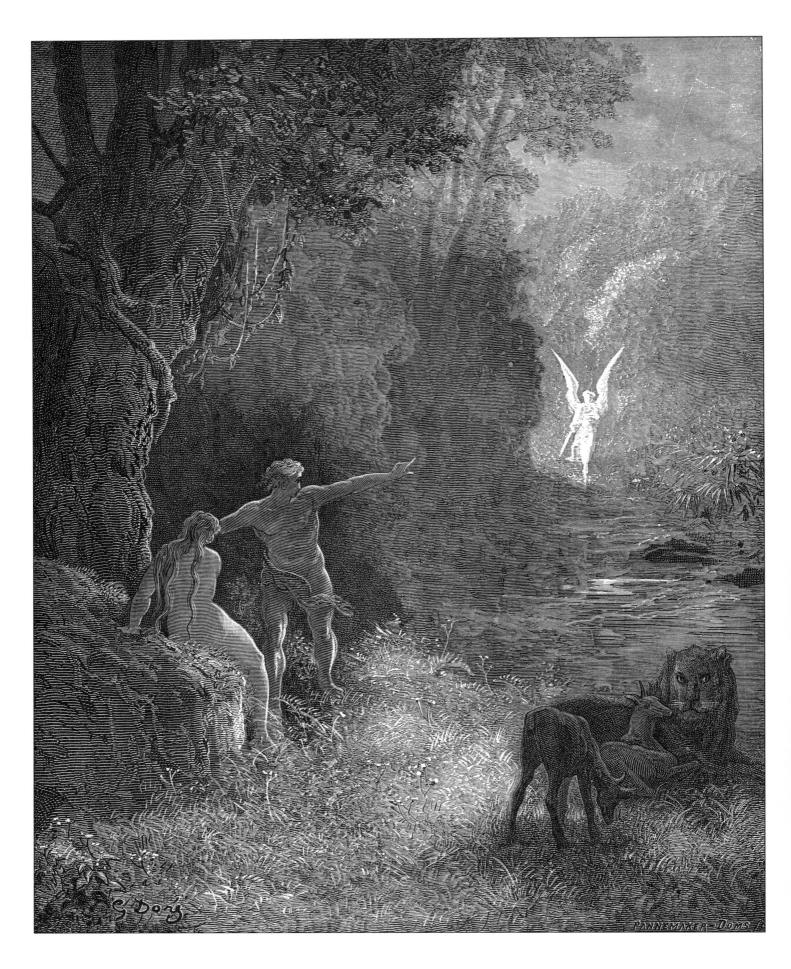

Eastward among those trees, what glorious shape
Comes this way moving?
(v. 309–310)

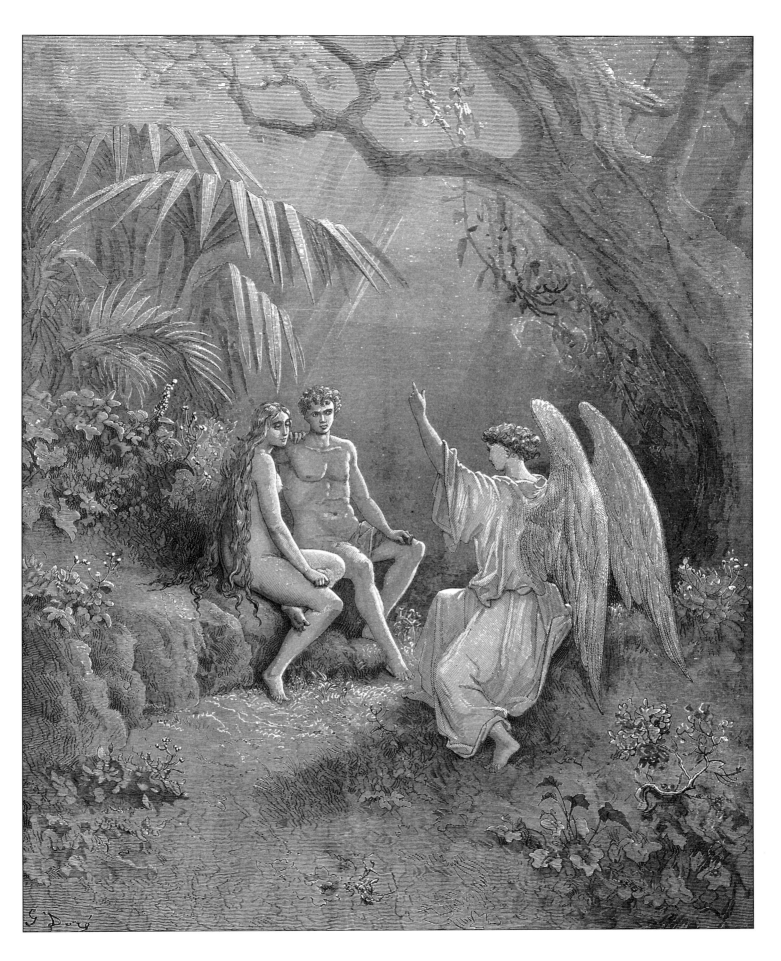

To whom the wingèd Hierarch replied:
O Adam, one Almighty is, from whom
All things proceed
(v. 468–470)

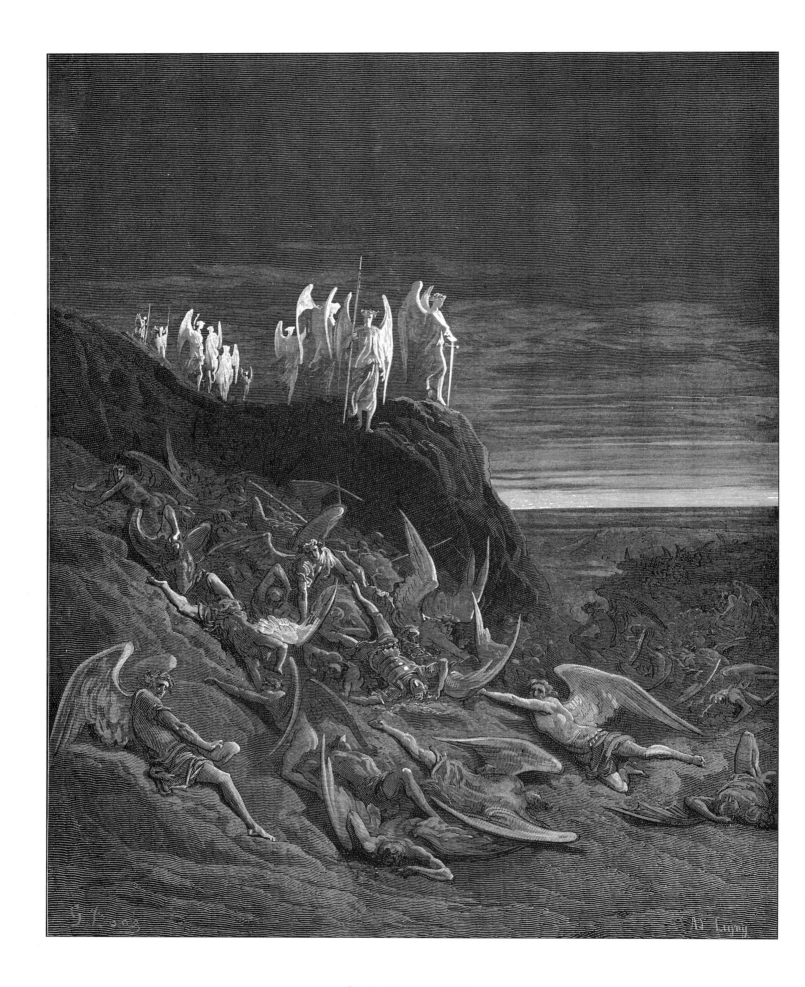

On the foughten field
Michael and his angels, prevalent
Encamping, placed in guard their watches round
(VI. 410–412)

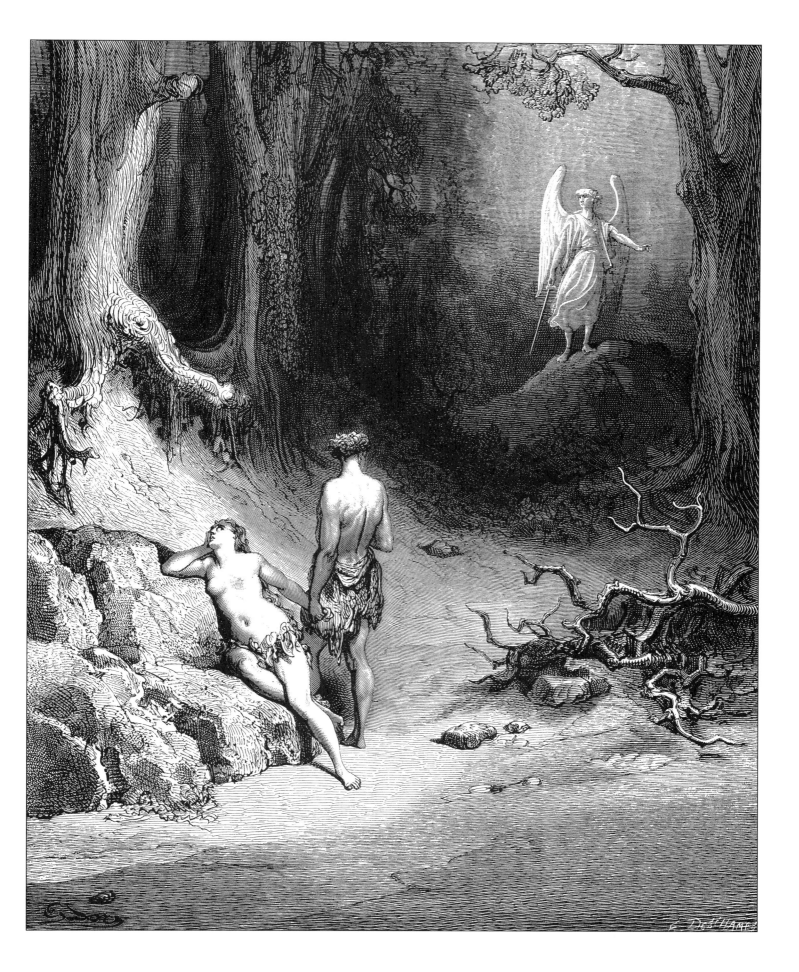

Some natural tears they dropt, but wiped them soon (XII. 645)

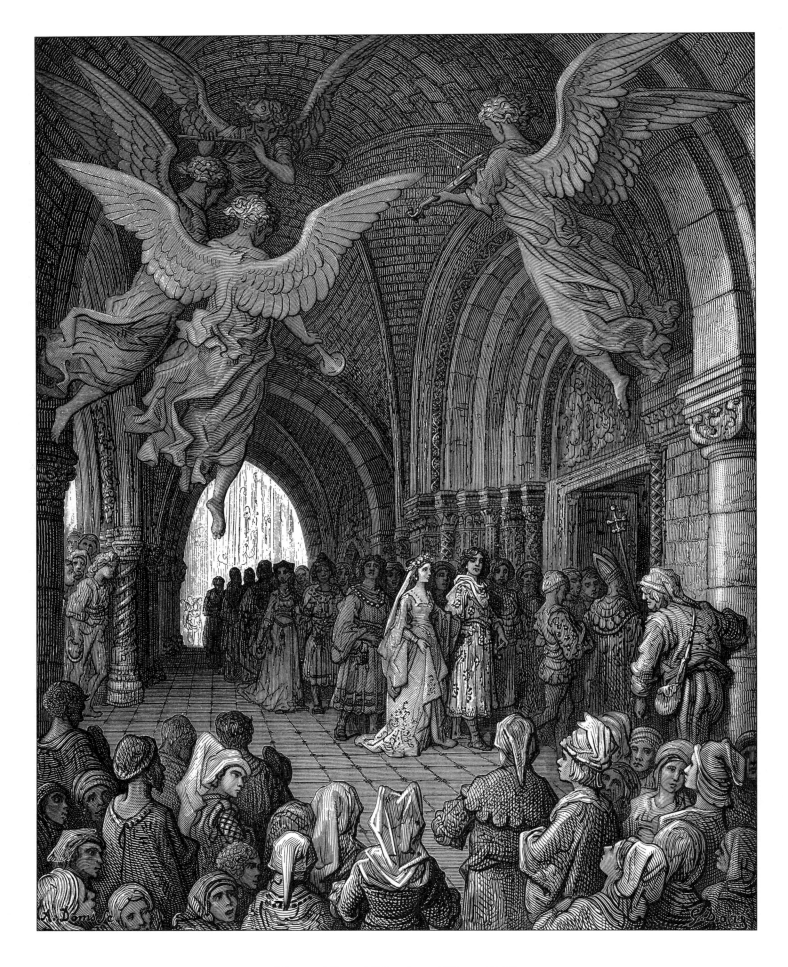

The wedding of Olimpia and Bireno (9:94)

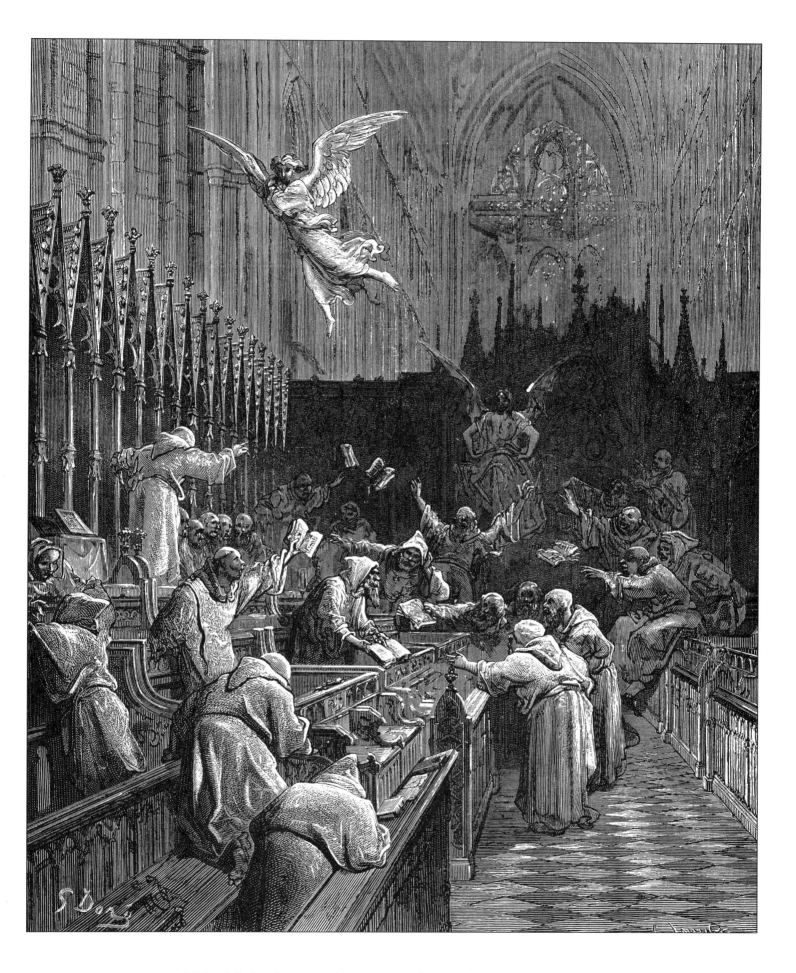

Michael finds Discord presiding over an election in the monastery (27:37)

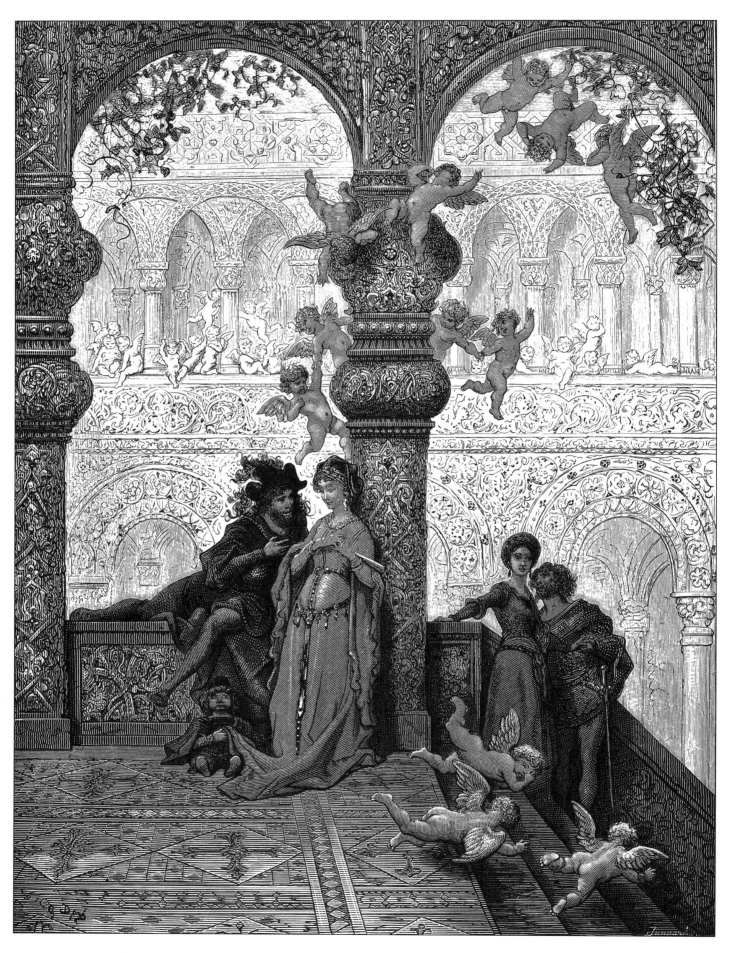

King Astolfo of the Langobards and Iocondo Latini travel all over Europe incognito,
making love to beautiful women (28:48)

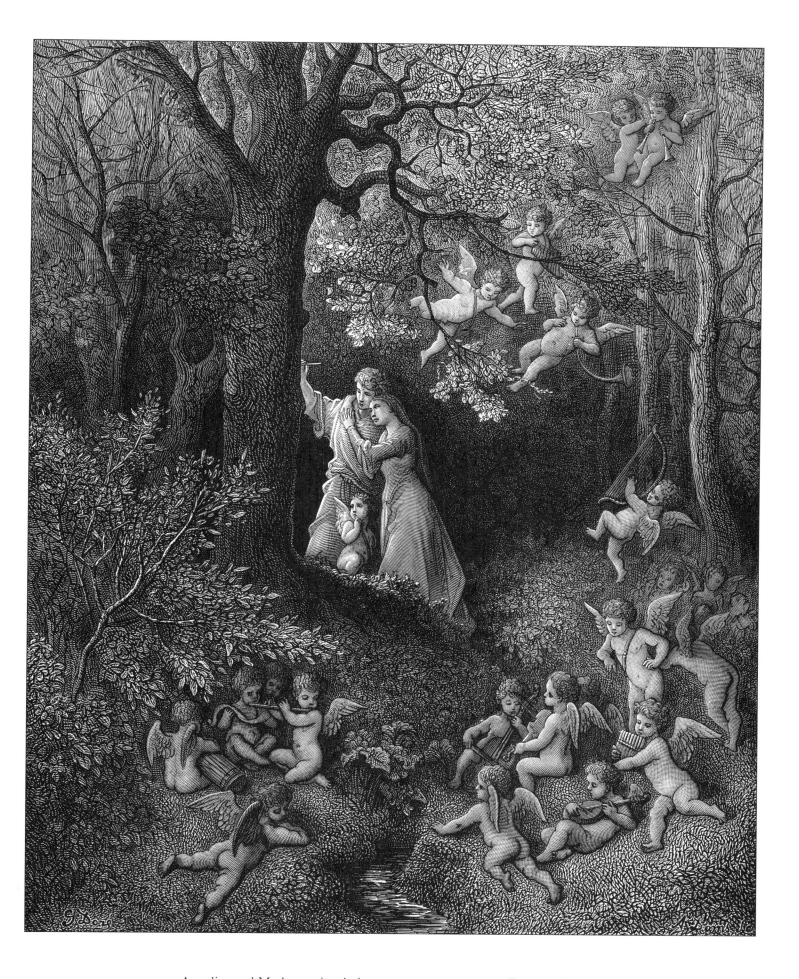

Angelica and Medoro write their names on every surrounding tree (19:36)

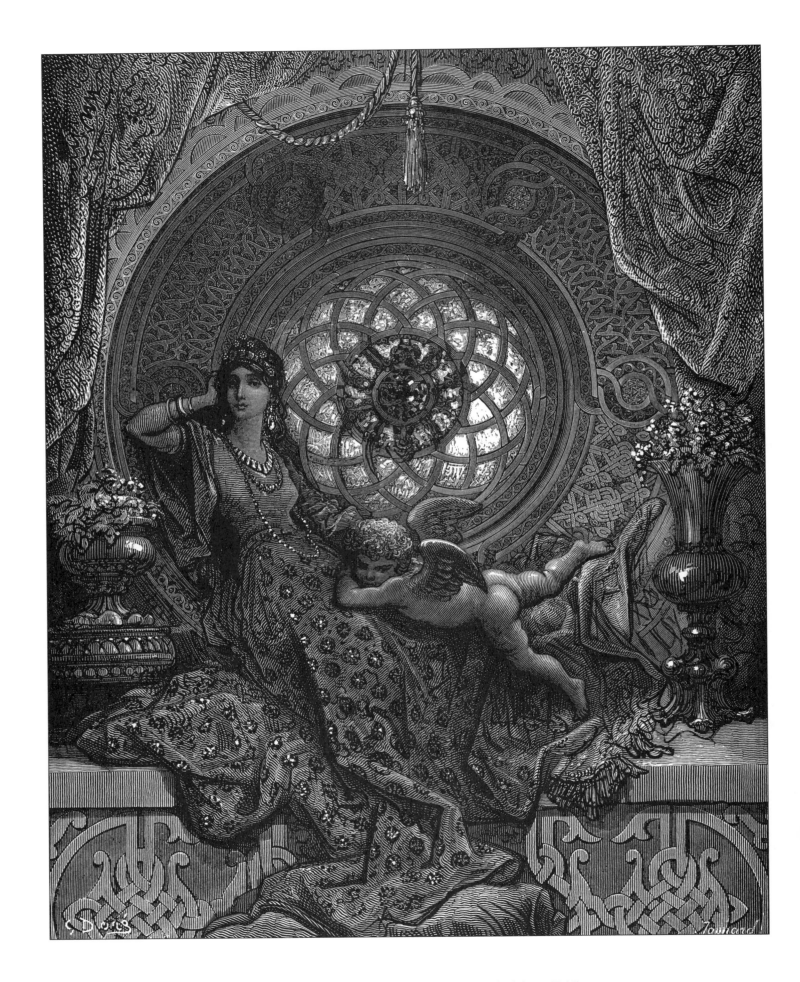

Alcina's beauty overcomes all of Ruggeiro's misgivings (7:16)

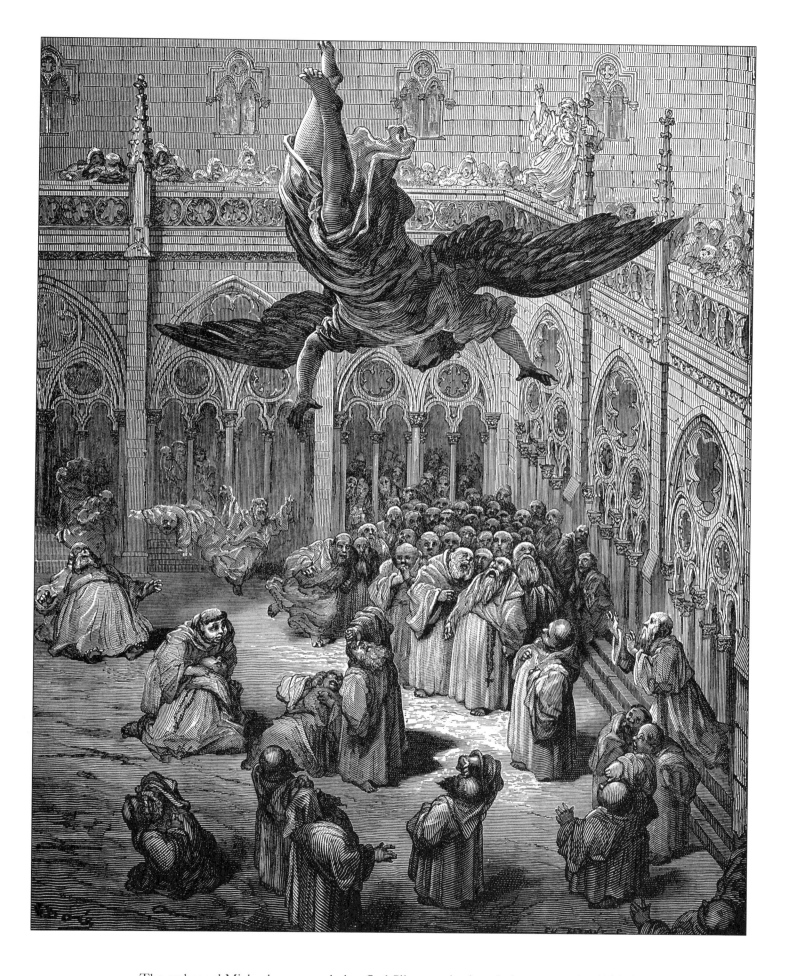

The archangel Michael, commanded to find Silence, tries in vain in monasteries (14:80)

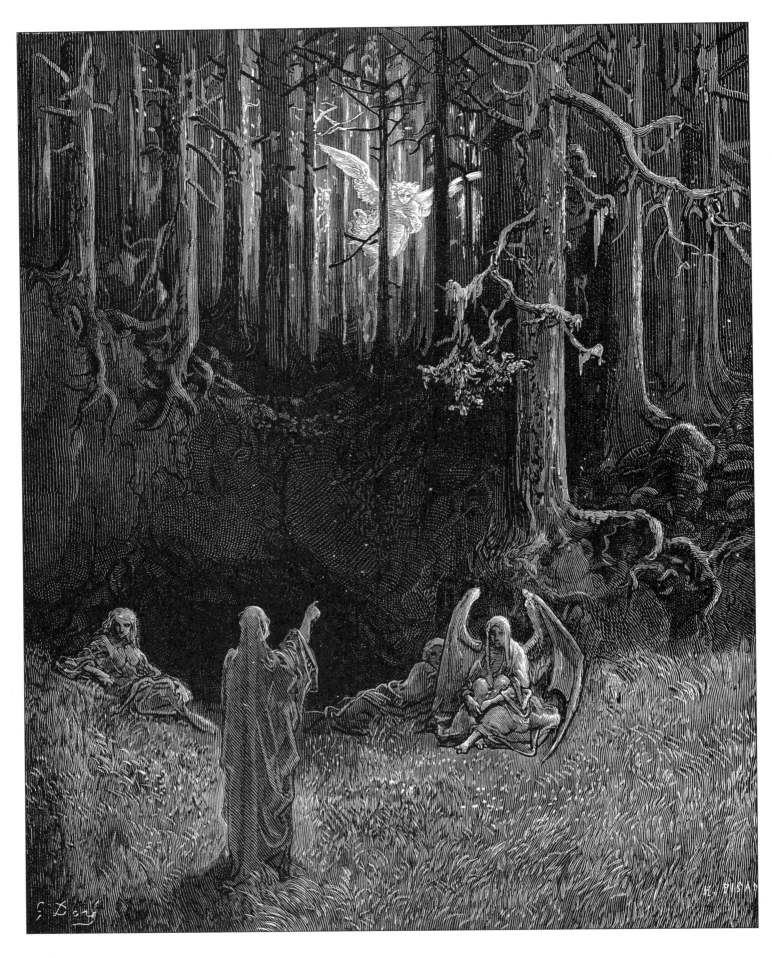

Michael finds the abode of Silence, who is accompanied by Sleep, Idleness,
Sloth, and Forgetfulness (14:93)

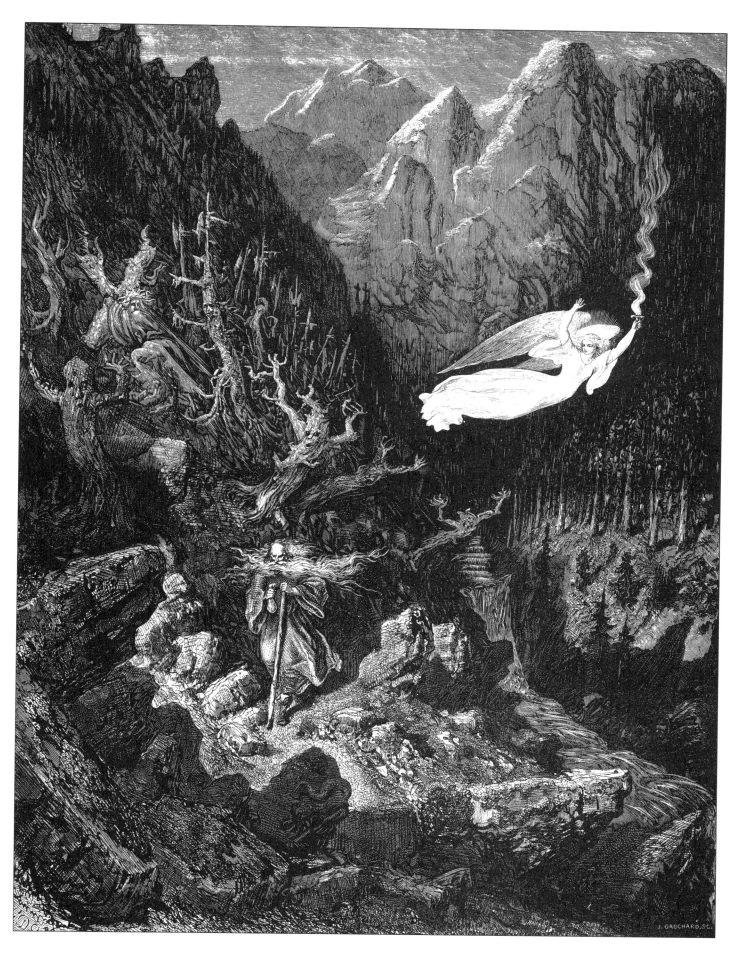

Now when fantastic visions fill the air,
Sorrow surrenders to a dull despair.

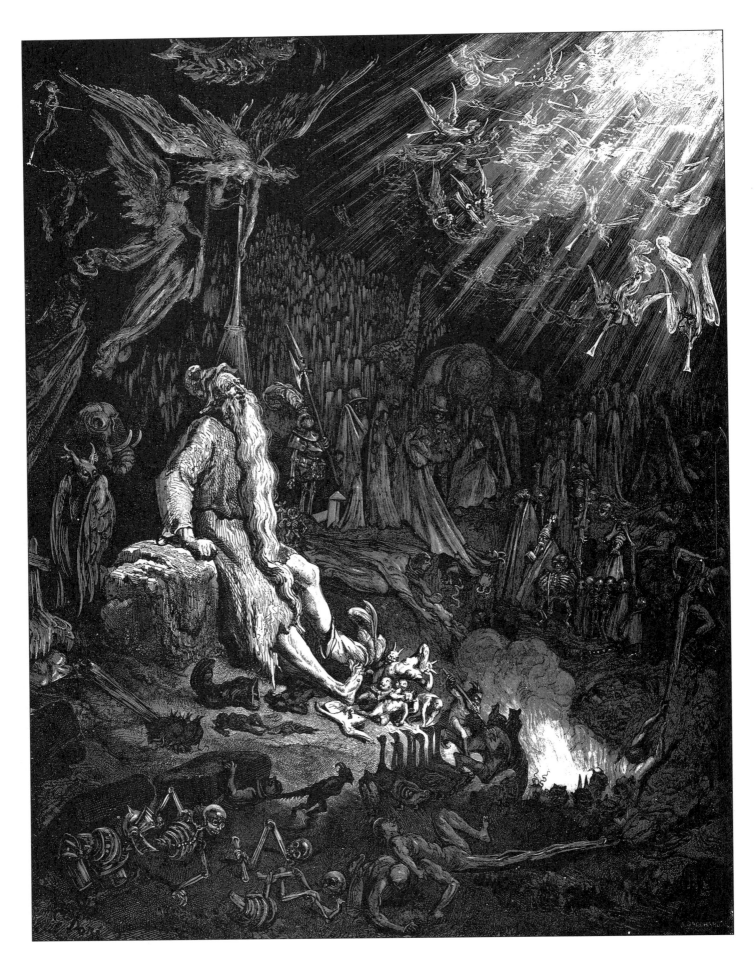

The Judgment Day! He hears the trumpet's blast;
And, prostrate, owns his Saviour's love at last.

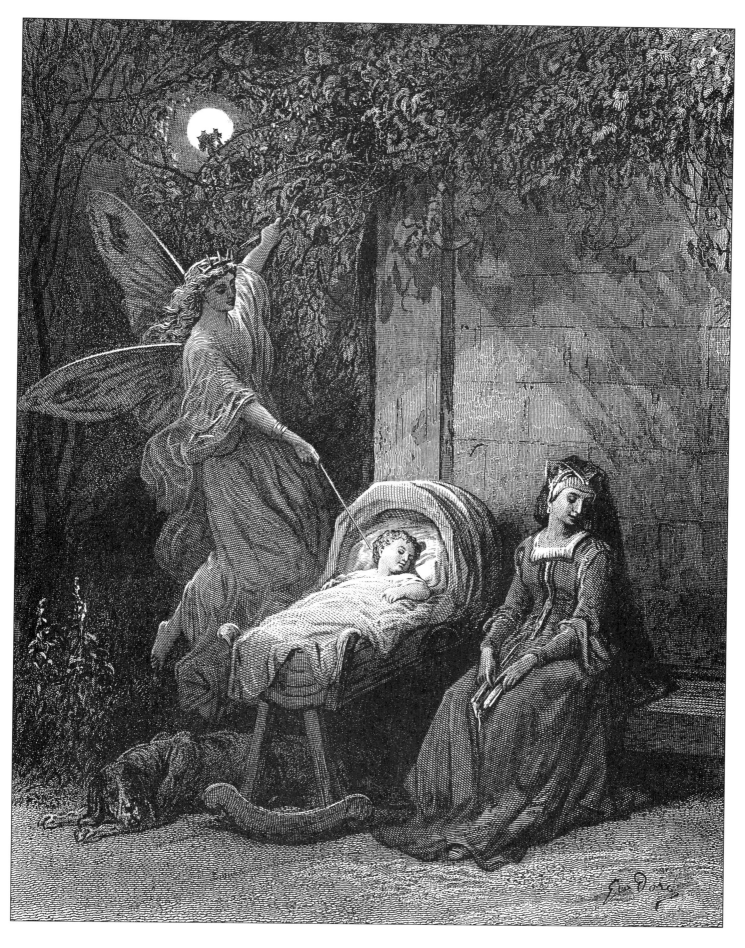

"QUEEN MAB"
Good Fairy with sleeping baby